PAST & PRESENT

WOODMONT

OPPOSITE: Merwin's Point House was the earliest hotel in Woodmont, probably opening as a tavern and inn for travelers in the mid-1800s. Merwin's Point was one of Woodmont's most famous landmarks. It was also the unofficial dividing point between the borough of Woodmont on the east and the tri-beach area also known as Woodmont on the west. (Author's collection.)

PAST & PRESENT

WOODMONT

Katherine Krauss Murphy

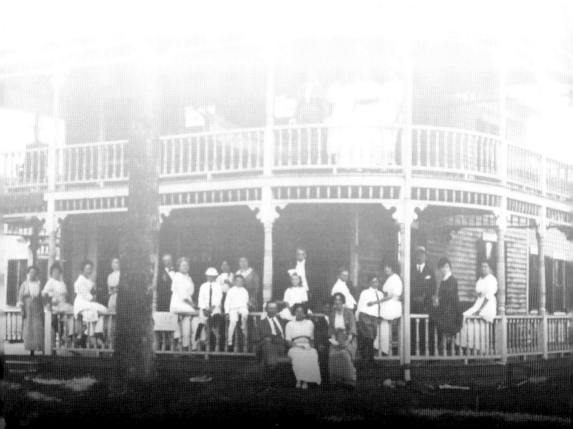

Looking back, I dedicate this to Scribner and Susan Bliss, who provided thousands of Woodmont residents and visitors with meals, memories, friends, and a home away from home for nearly half a century.

Looking ahead, may my grandchildren Allie, Ethan, and Elijah take part in the preservation of Woodmont and our world.

Copyright © 2023 by Katherine Krauss Murphy
ISBN 978-1-4671-0966-6

Library of Congress Control Number: 2022950993

Published by Arcadia Publishing
Charleston, South Carolina

Printed in the United States of America

For all general information, please contact Arcadia Publishing:
Telephone 843-853-2070
Fax 843-853-0044
E-mail sales@arcadiapublishing.com
For customer service and orders:
Toll-Free 1-888-313-2665

Visit us on the Internet at www.arcadiapublishing.com

ON THE FRONT COVER: Crescent Beach in Woodmont, Connecticut, was a rugged and rocky beach but home to some of the area's nicest homes. Despite its rocky shore, it was popular for boating and fishing as well as a view of Signal Rock, a landmark older than the name Woodmont itself. (Author's collection.)

ON THE BACK COVER: Not only have buildings, landscapes, transportation, businesses, and leisure changed over the past century, but bathing suits also look radically different. Men's bathing suits had to cover their chests; women used to cover up their legs as well. Over the years, there were strict modesty requirements and local enforcement related to swimwear. At Anchor Beach in Woodmont in the 1920s, a policeman was stationed at the beach to check residents' identification and inspect the bathing attire, including neck-to-knee beach robes. (Author's collection.)

Contents

ACKNOWLEDGMENTS

I would like to thank George Peacock, my research and editorial consultant. I am also grateful to the following people for their help: Philip and Mary Ellen Allspaugh; Andy Blair (Flickr.com/WAVZ13); Woodmont warden Edward Bonessi Jr.; Colin Caplan; Michael Clark; Pat Collins; Kathy Daniels; Nancy Dunbar; David Fischer, MD; Sonya, Saul, and William Goldberg; Bob Granger; Bruce Kerzner; Toni (Lee) Moldenhauer; Joe Mursko; Irene Nolan, David Purcell; Irv and Larry Pinsky; Juliet (Velleco) Russell; Christopher Scanlon; Walter Poli Sheahan; Edward Surato; Lowell Beach Sykes; Rob Vano; and John Void. I thank the following organizations for their help and their critical role in preserving history: Antiquarian and Landmarks Society, Hartford, Connecticut; Bagel Beach Historical Association (bagelbeach.com); Milford Historical Society; Borough of Woodmont's Joseph Holt Collection; and the Whitney Library, New Haven Museum.

The US Library of Congress (chroniclingamerica.loc.gov) provided numerous digitized articles shedding light on the history of Woodmont, including the following newspapers: *New Haven Morning Journal and Courier*, *Connecticut Western News*, *Bridgeport Evening Farmer*, and *Norwich Bulletin*. Additionally, the New Haven Museum's copies of the *Saturday Chronicle* from 1903 to 1916 were invaluable. Also helpful were *The History of Milford, Connecticut*, published in 1939 by the Milford Tercentenary Committee and the US Work Projects Administration; Milford City Directories 1909, 1913, 1916, and 1917; and two local Facebook groups: Anchor Beach . . . Woodmont Days and Milford, CT History & Vintage Images.

Unless otherwise noted, all past and present images are from the author's collection.

INTRODUCTION

For hundreds, if not thousands, of years, the Paugussett tribe of pre-America inhabited the area that would later become Milford. But on August 22, 1639, white Anglo settlers from the New Haven Colony, led by a preacher named Peter Prudden, came to create their own settlement near the river the Paugussetts called Wepowage. Six months earlier, they had purchased the land from Ansantawae, chief sachem of the Paugussetts.

The land was perfect for the settlers: the soil was fertile, the game was plentiful in the forests, and Long Island Sound was rich with clams, oysters, blue crabs, lobsters, and fish.

Twenty years later, in 1659, two of the original Milford settlers, Alexander Bryan and Robert Treat, renegotiated with Ansantawae for the land between the Indian River and Oyster River, which included the section of Milford that would become Woodmont. For the next 200 years, this parcel of land was simply known as Burwell's farm east of Indian River and Merwin's farm west of Oyster River.

Survival was the sole focus for the next 200 years. But the town was settled; homes, churches, and schools were built, a government and rules were established, and the United States of America formed after a painful revolution with Great Britain.

Shortly after the Civil War, life began to get a bit easier for New Englanders, and there was time for recreation and leisure. People from other towns and cities in Connecticut yearned to escape the summer heat. They discovered the shorefront of Woodmont and other areas along Long Island Sound. The shore was rocky and unsuitable for farming but pristine and beautiful. In 1874, the Reverend Dr. Joseph Anderson, a pastor from Waterbury, built the first waterfront summer cottage in Woodmont, near Oyster River. Later that year, Charles and Angelina Perkins, also of Waterbury, built the second beach cottage about a mile away, at Merwin's Point. A few inns and hotels had opened by this time.

The concept of a summer resort, with hotels, restaurants, and beach cottages, began to take hold. Early on, this budding vacation area was simply called Merwin's Point. It was named after Miles Merwin, originally from Plymouth, England, who settled in Milford in 1645.

The name "Woodmont" came into being in the 1870s. It was suggested by a Waterbury father and son: James Ayres, a jeweler and Methodist minister, and Russell Ayres, an attorney. Russell gave the name "Woodmont" to the area because of the elevated, wooded bluff above Long Island Sound. He graduated from Harvard Law School at the age of 26, but because of his poor health, he and his father moved to a farm in Milford in 1872, not far from Merwin's Point.

Around this time, the Ayres recommended Woodmont to Rev. Joseph Anderson for the location of his beach cottage. Their dream was to turn Woodmont into a summer resort. Sadly, Russell died a year later, and his father moved into Woodmont, where he managed chapel services and occasionally preached at Woodmont Union Chapel.

Horse-and-buggy was the main mode of transportation at the time, and in 1874, the Ayres negotiated successfully to establish a train station (at the end of what is now Depot Road), which would later become the New York, New Haven & Hartford Railroad.

Train transportation was augmented in 1893 when trolley service was extended into Woodmont from New Haven and the Savin Rock amusement park in West Haven. Trolleys made the area accessible from the nearby cities. Suddenly, Woodmont—which had consisted of a few family farms, rocky terrain, and undeveloped marshland—became valuable real estate. Most early visitors to Woodmont stayed at inns and hotels. After the arrival of trains and trolleys, more private cottages began to spring up, and by 1891, there were over 100 cottages in Woodmont.

During the Gay Nineties, Woodmont began to acquire a reputation as a highly desirable summer vacation spot. Two areas shared the name "Woodmont." East of Merwin's Point was the area that would eventually become the borough of Woodmont. But the three beaches west of Merwin's Point—Merwin's, Burwell's, and Farview—were also known as Woodmont.

The cottagers in the east soon organized to meet the needs of the community. In 1901, they formed the Woodmont Association, a community improvement association. Two years later, Woodmont was granted a charter from the state legislature and became a borough within the town of Milford on June 18, 1903.

The cottagers west of Merwin's Point were slower to organize but developed a thriving summer community. The cottages here were more modest, but the beaches were sandier, particularly Merwin's Beach. Shortly after World War I, this area began to develop as a summer enclave for Jewish families from New Haven, other towns in Connecticut, New York, and other states. It was affectionately called "Bagel Beach" by residents and nonresidents alike. There was even a summer synagogue on Merwin Avenue, the Hebrew Congregation of Woodmont.

Between the 1890s and World War II, both sides of Merwin's Point—now universally called Woodmont—flourished in the summer. Summer dwellers had a thirst for recreation, relaxation, and leisure—concepts that would have been unimaginable to the original Milford settlers. The entertainment was endless: tennis courts, a country club, a golf club, croquet, restaurants, dances known as "hops," a popular card game called whist, swimming and boating races, band concerts, plays, festivals, and fireworks.

However, the Great Depression and World War II spelled the end of Woodmont's golden days. Hotel business declined, cottages were winterized, and automobiles and airplanes allowed people to vacation anywhere. Television and air-conditioning provided the entertainment and cool air that early cottagers once sought. Schools, libraries, fire stations, and post offices were centralized citywide, and smaller ones closed in many beach communities.

But the magnetism of salt water, fresh air, and sandy and rocky beaches remained. Even as quaint cottages were torn down to be replaced by grand, and occasionally grandiose, three-story homes, a sense of community survived in both the borough and the tri-beach neighborhood.

Recreation and relaxation still mattered but were manifest in new ways: skateboarding, basketball, and pickleball took the place of croquet, dances, and card games. Boating remained, although there were fewer rowboats and more jet skis, windsurfers, and kayaks. Barns and outhouses became obsolete and were torn down or converted to garages. Trolleys were gone and cars took over. Front porches disappeared and then started to come back. Some old homes became unrecognizable; others were restored and preserved. Fishing hardly changed at all.

Somehow the sanctity of the neighborhood survived. Neighbors became friends and looked after one another. Residents knew the names of the nearby cats and dogs, the rocks, trees, beaches, and land formations. Memories of this special place were revered and passed down to the next generation. Nothing stays the same, but Woodmont is still Woodmont.

BEACHES

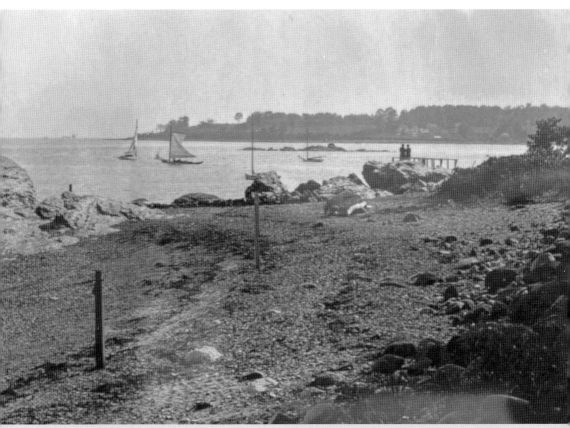

Before Woodmont was named, it was called Merwin's Point after the promontory that was between the beaches on its eastern and western sides. The foreground of this photograph, from an early glass negative, focuses on the east, where Crescent Beach and Anchor Beach meet. In the distance is the western side of Woodmont—Merwin's, Burwell's, and Farview Beaches.

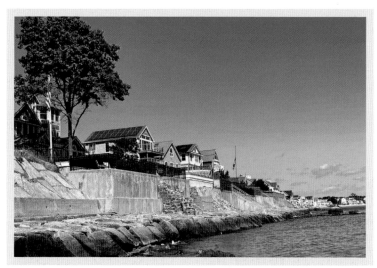

Just before Morningside is Farview Beach, a tiny beach between South, Paris, and Farview Streets. Farview Beach has suffered devastating effects from hurricanes and nor'easters. The lawns and beaches are gone, replaced by fieldstone walls, concrete berms, and Stony Creek granite blocks to slow erosion. On August 19, 1910, the *Bridgeport Evening Farmer* noted that the Connecticut Trolley Company sponsored Illumination Night, transporting thousands to the "triple beaches" to see a blaze of light, as Chinese lanterns illuminated the shore "from Burwell's Beach to the end of Farview."

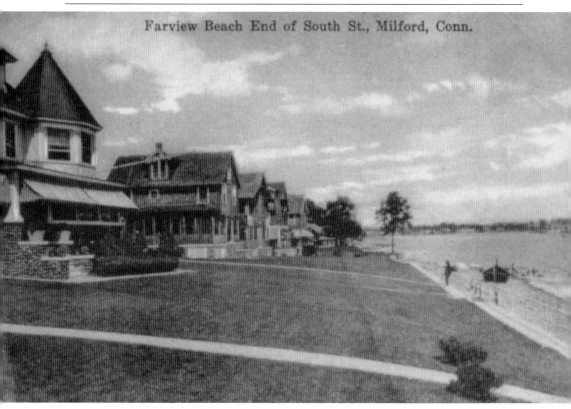

Farview Beach End of South St., Milford, Conn.

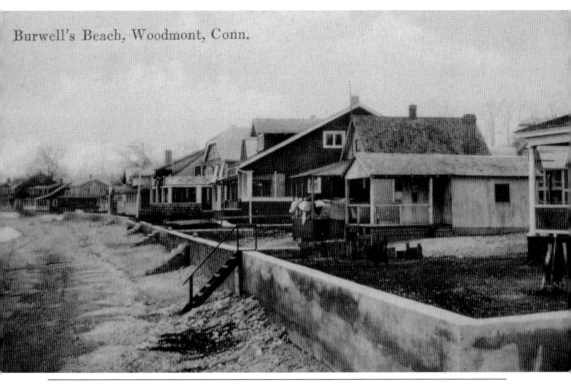

Burwell's Beach, Woodmont, Conn.

Burwell's Beach stretches from the beginning of Hillside Avenue to Burwell Avenue, right in the middle of the tri-beach neighborhood. Burwell's Beach was rockier closer to Farview Beach; both were called Rocky Beach, and both lost much of their shoreline during the Great Hurricane of 1938. Descendants of the Burwells, who had farmed the land in eastern Milford since the 1600s, still had a home called Sunny Farm at Burwell's Beach, where their niece Mamie was married on December 23, 1907.

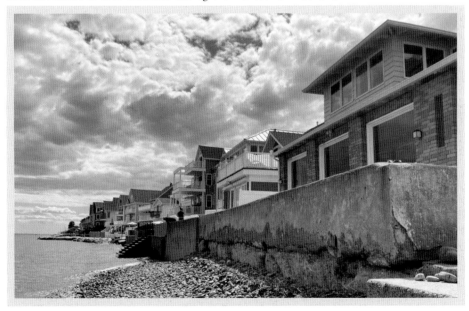

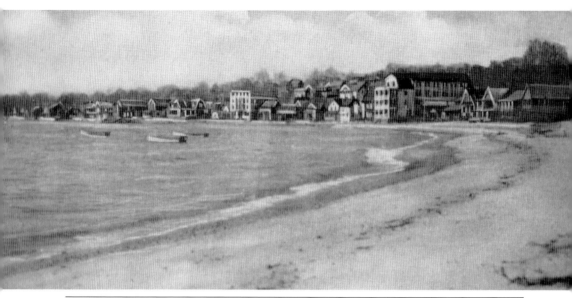

Merwin's Beach stretches from Poli's Point (named after Woodmont's most famous resident, Sylvester Poli) to the intersection of Hillside and Merwin Avenues, near the original Sloppy Joe's. Merwin's Beach was a popular summer destination for Jewish families after World War I, and eventually the tri-beach area—especially Merwin's Beach—was sometimes referred to as "Bagel Beach." The past photograph shows the beach around 1900; the color photograph was taken in 1963 by George Bologovsky. The identifying landmark is the four-story Hotel Sauter.

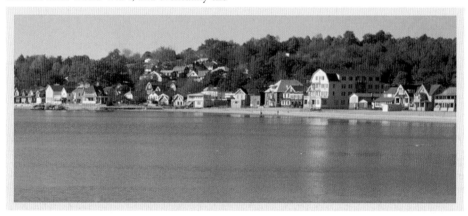

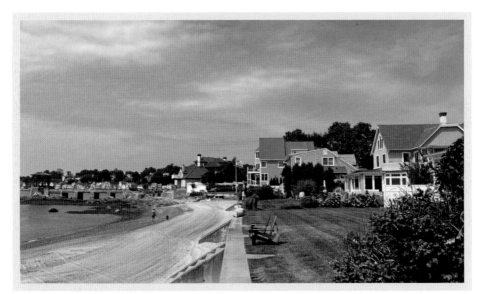

Pickett's Beach, seen here around 1907, has a name almost as obscure as the beach itself. Located between Merwin's Point and Poli's Point, this beach was mostly used by the guests of the area's oldest hotel—Merwin's Point House, later the Woodmont Lodge. The wooded outcropping of land on the left, called Lazy Rock, is where Poli built the Villa Rosa, his summer home, around 1913. Offshore is a large rock known as Barrow's Rock or submarine rock, adorned with a flagpole in the early 2000s.

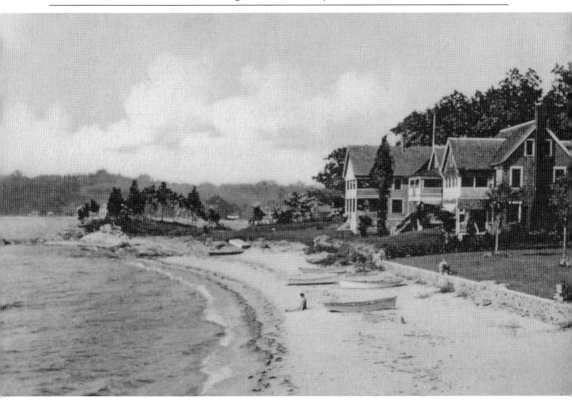

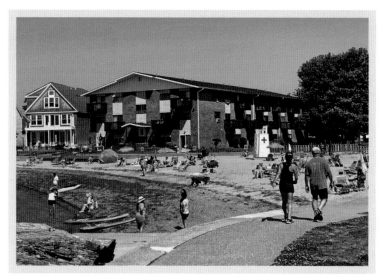

For many years, Anchor Beach, Woodmont's most popular beach, was called Sandy Beach. Adjacent to Merwin's Point, it was the only naturally sandy beach in the borough. The beaches west of Merwin's Point, on the other hand, had long stretches of sand, especially Merwin's and Burwell's Beaches. At some point in the 20th century, Sandy Beach became Anchor Beach. Right across the street was the Anchor restaurant. Only history knows which came first—Anchor Beach or the Anchor restaurant.

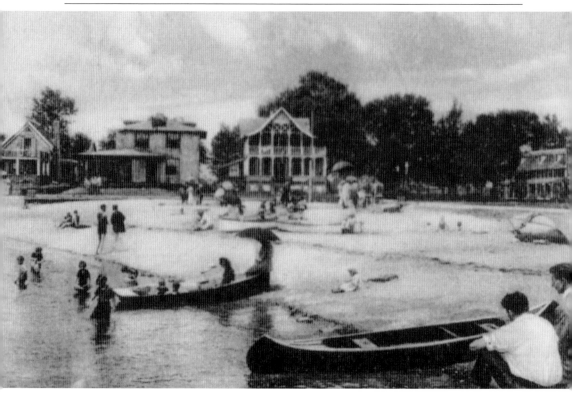

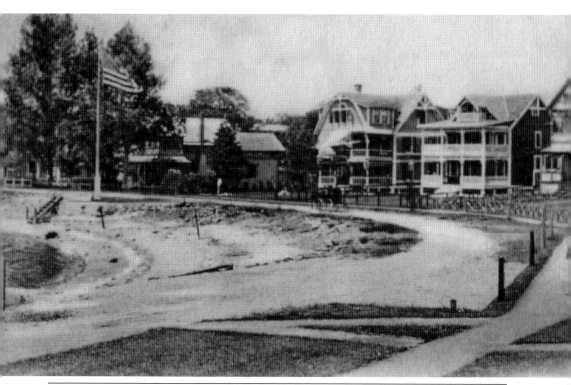

Between Randall's Point and Blakeslee's Point lies a crescent-shaped beach lined with some of Woodmont's most impressive cottages. But unlike nearby Anchor Beach, Crescent Beach was pebbly and rocky—used less for bathing and more for mooring small rowboats and dinghies for fishing and sightseeing. The 1906 photograph shows more beach than the current view. The borough maintains a concrete wall to prevent high tides from crossing over Beach Avenue, but serious erosion remains a real concern.

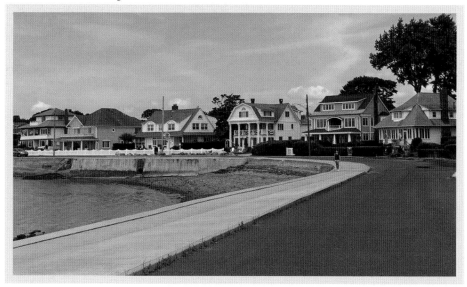

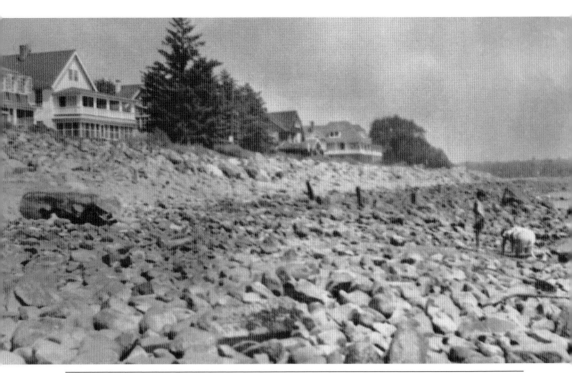

Middle Beach, between Woodmont Avenue (Usher Street) and Belmont Street, was a rocky mess before the borough attempted its first beach restoration project in 1957—not just to make the beaches more enjoyable but to protect streets, underground utilities, and shorefront homes from erosion. Anchored 200 feet offshore, a large dredge attached with long pipes sucked up the sand that had been dragged out by tides and storms and pumped it onto the shore. While not a permanent solution, the results lasted many years.

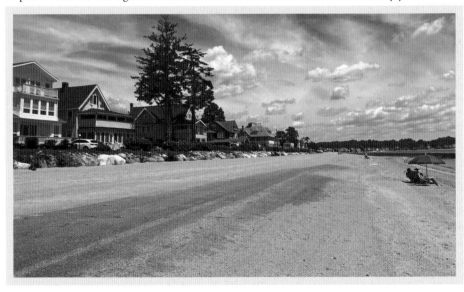

Anderson Avenue beach is one of the few areas with beachfront property. Beach restoration has paid off, as the 1917 postcard shows less sand than the current photograph. Rosemary Cottage (center of both photographs) was Woodmont's first summer beach cottage, built in 1874 by Rev. Joseph Anderson. The cottage and its original barn are relatively unchanged and secluded due to beach grasses, shrubs, and trees, including an old copper beech tree, which is protected by Oyster River Bay.

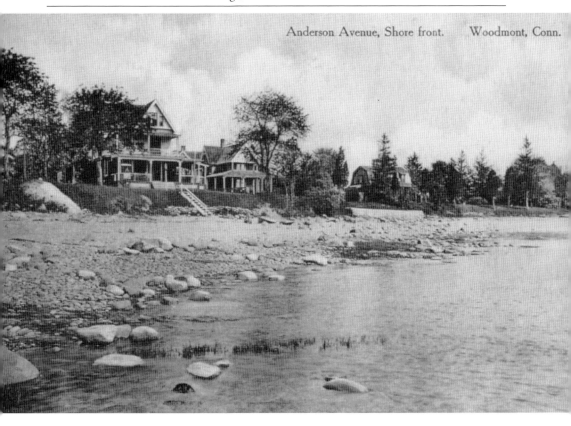

Anderson Avenue, Shore front. Woodmont, Conn.

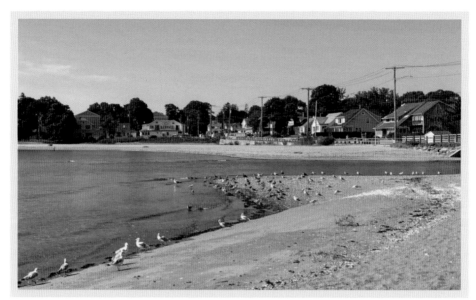

Years ago, Oyster River Beach was popular for clamming and oystering, but today, bird-watching and beachgoing are more common. Oyster River forms the boundary between Woodmont and West Haven. With the river on one side of the street and the sound on the other, water can occasionally breach the bridge, but the beach has been the beneficiary of Woodmont's beach restoration efforts over the years and has accumulated sand drifting over from Woodmont.

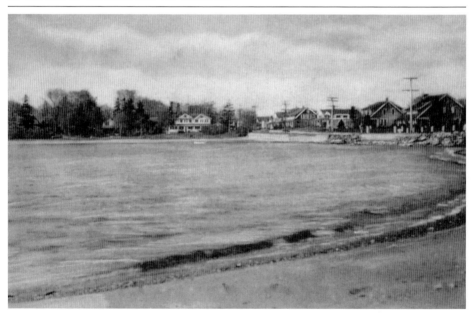

HOTELS AND INNS

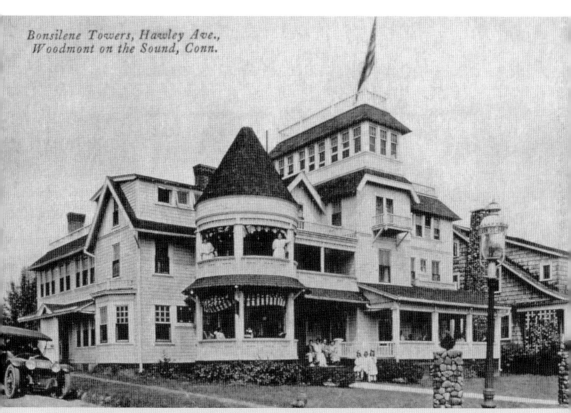

*Bonsilene Towers, Hawley Ave.,
Woodmont on the Sound, Conn.*

Bonsilene Towers, at 42 Vue de L'eau (Hawley) Avenue, was just as handsome as its cousin, the Bonsilene Hotel, two doors away. Both were started by Olin H. Clark, a realtor from Hartford who promoted his hotels and shore lots through newspaper advertisements. Bonsilene Towers was destroyed by a fire in the 1950s, and a small house was built there in 1983.

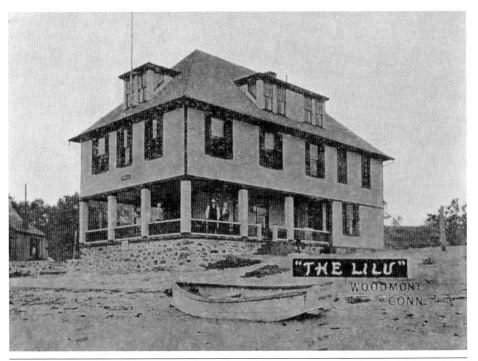

Alfred Butler of New Haven built the Lilu House on Merwin Avenue in the 1890s, shown here in 1907, just beyond the Hotel Sauter. Henry Northnagle was the proprietor for many years. On the annual tri-beach Illumination Night, the August 21, 1908, issue of the *New Haven Morning Journal and Courier* reported, "Perhaps the handsomest illumination was at the Lilu Cottage where there were upwards of 300 Japanese lanterns." The Lilu and the rest of the block were torn down in 1999 for the Villa D'Oro, a 12-unit condominium.

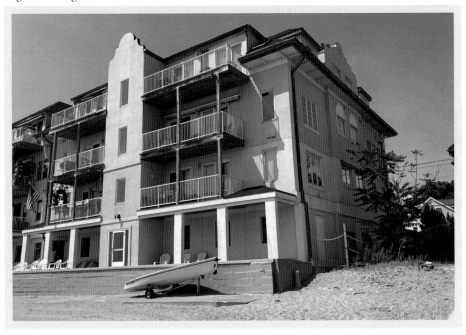

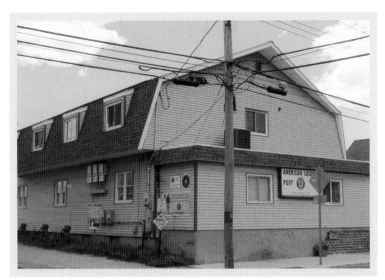

A public auction was held in 1936 for the four-story Hotel Sauter, built around 1900, with 46 sleeping rooms and dining, bath, and cooking facilities. In 1958, the building—then a rooming house known as the Parskey Hotel—was for sale for $57,000. In 1966, the property at 25 Merwin Avenue was bought by the American Legion East Shore Post No. 196. The second and third floors were removed, the roof was lowered, and today, the building is a popular social hall for US veterans.

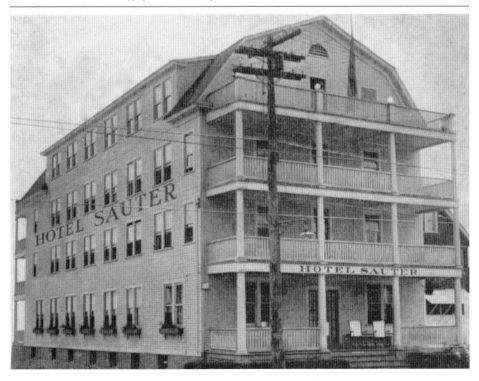

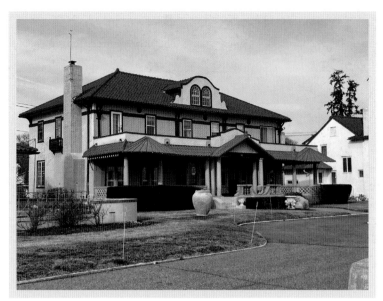

Merwin's Inn began as a restaurant around 1875, but later, an inn was added in front of the restaurant. Around 1917, Merwin's Inn was renovated and called the New Merwin's Inn. By 1922, theater owner Sylvester Poli had purchased it and started building a seawall and several large Mediterranean "cottages" for his family near the Villa Rosa, his summer house. Completed in 1925, this was the first and largest of the cottages; today, it is a duplex home where a great-grandson of Sylvester and Rosa Poli lives.

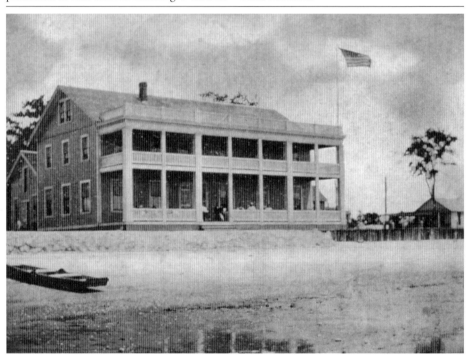

HOTELS AND INNS

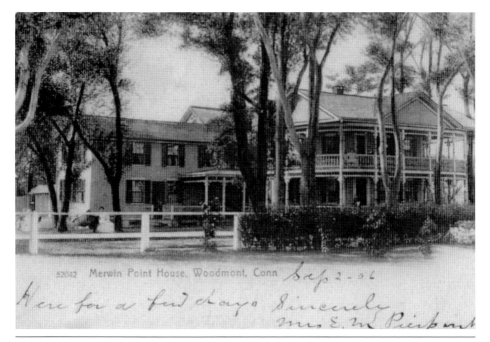

52042 Merwin Point House, Woodmont, Conn *Sep 2 - 06*

Here for a few days. Sincerely, mrs. E. M. Pierpont

Merwin's Point House, in this 1906 postcard, was the first inn in Woodmont. It was listed on an 1868 map as Merwin's Point Watering Place, owned by Miles Merwin. Later, it was owned by Mark Merwin and then by his widow, the beloved "Aunt" Abigail Merwin. When she died in 1896, all the flags in Woodmont were lowered to half-mast. It later became the Woodmont Lodge, and then condos. All that remains of the old hotel is the wooden skeleton and the fieldstone chimney.

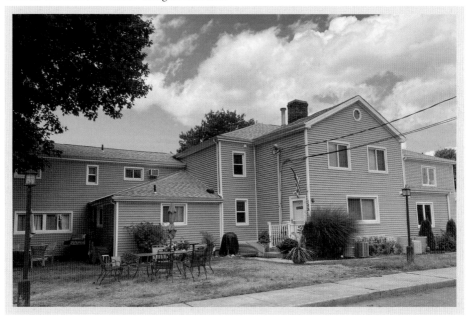

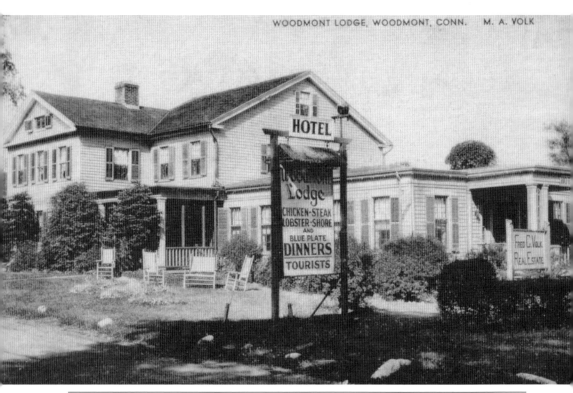

After the Depression, George and Molly Volk, who had owned the Hotel Volk in New Haven, bought Merwin's Point House and renamed it the Woodmont Lodge (shown here in a postcard postmarked 1939). The lodge featured a large dance hall and library, live music, and popular shore dinners. In 1960, the Volks sold it to Thomas and Sarah Turnball, who continued to run the inn, but its popularity waned. The building was sold in 1987, gutted, and converted to six apartments called Woodmont Shores, at 182 Kings Highway.

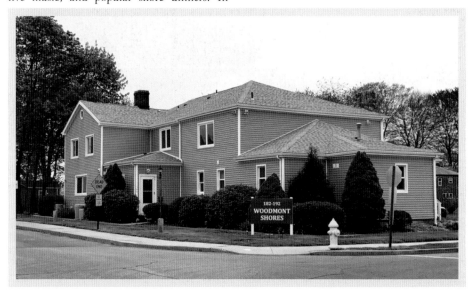

George W. Sanford managed the Pembroke Hotel in 1880 and Merwin's Point House in 1883. He was so popular at the Merwin's Point House that residents referred to it as the Sanford House. By 1895, he had opened his own hotel across from Anchor Beach, which he called the Sanford House. That July, he hosted an outdoor band concert and had fireworks set off Great Rock. Today, it is the Pelican Cove condominiums.

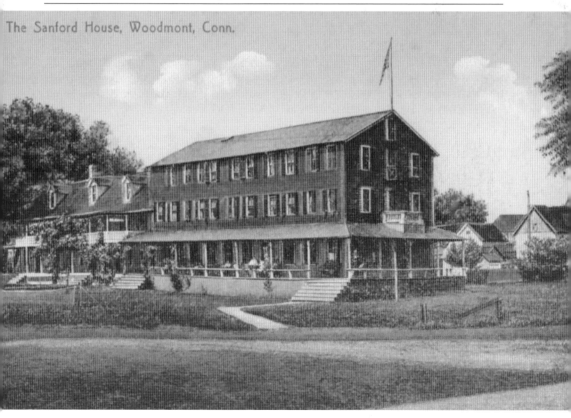

The Sanford House, Woodmont, Conn.

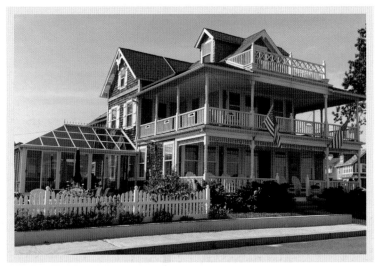

Little is known about the Silver Bow, built around 1900 at 90 Beach Avenue. It may have been a family cottage, an inn, or a guesthouse. The pronunciation of "Bow" might be "bough" or "beau." The Greek goddess Artemis was the huntress with the silver bow. Maybe it was the silver-painted bow of a rowboat. The current owner bought it from his grandfather in 1999 and meticulously restored it close to its original condition. (Past image, courtesy Joseph Holt Collection.)

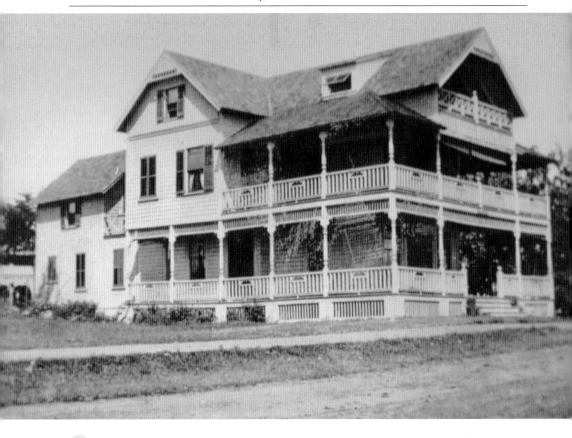

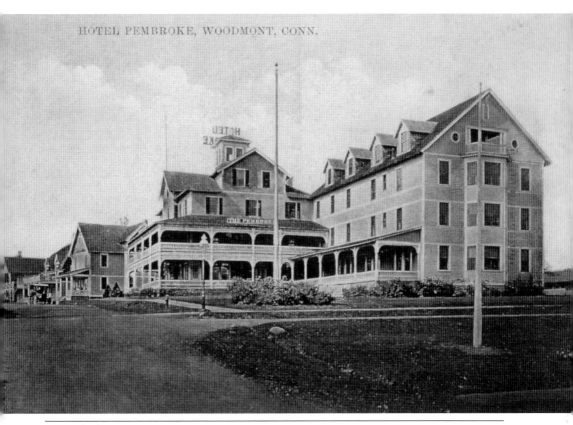

The Pembroke opened in the 1870s and may well have been the largest and most handsome hotel in Woodmont. In 1881, the hotel was managed by J.S. Rood. Later, William Phillips became the Pembroke's most well-known proprietor, and he added a large addition in 1906. After a fire in the 1950s, the hotel was torn down to build the Seaside Convalescent Hospital at 18 Chapel Street in 1959. Today, that building houses nine condos.

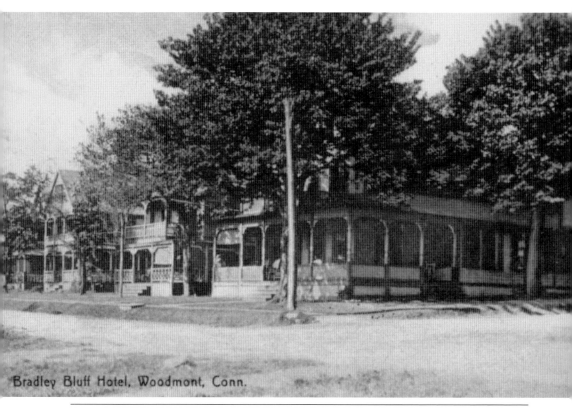

Bradley Bluff Hotel, Woodmont, Conn.

In the 1890s, the Bradley brothers opened the popular Bradley Bluff Hotel at 60 Hawley Avenue. According to a 1900 advertisement, they catered to "persons of impaired health and all who are in search of rest and recreation." In 1902, Minot Bradley tried to rescue a drowning child, but the panicked boy nearly strangled him. A vegetable peddler jumped into a rowboat that had no oars but saved the boy and an unconscious Bradley. It later became a health facility and now is apartments. (Past image, courtesy George Peacock.)

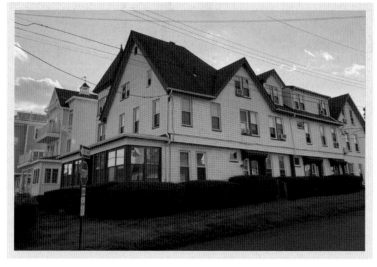

HOTELS AND INNS

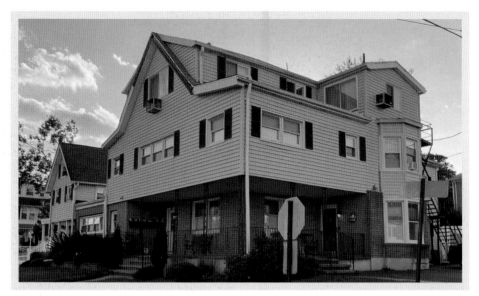

Around 1900, the Ellamay Cottage was a single cottage with rooms to rent. The September 17, 1907, issue of the *New Haven Morning Journal and Courier* reported that "Miss Julia Bronson, who spent the summer in Kennebunk, ME, is spending September at the Ellamay Cottage, Woodmont." After the owner bought the cottage next door and attached the two, it became the Elmay Hotel. This 1957 real estate photograph shows the hotel available for $27,000; it was still open in 1964. Today, it houses 10 apartments at 54 Hawley Avenue.

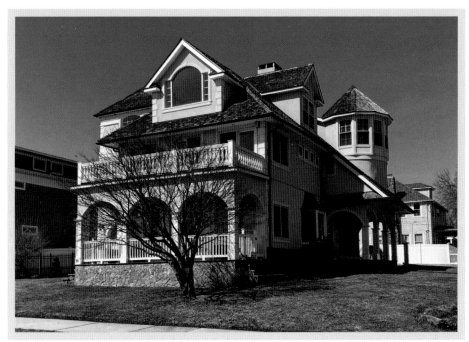

The Bonsilene Hotel, at 36 Hawley Avenue, was started by Olin H. Clark of Hartford, who also laid out the park in front of the hotel. It opened in the 1880s, if not sooner, as Woodmont's third hotel, after Merwin's Point House and the Pembroke. The Bonsilene is one of the few old hotels that retained its looks throughout the 20th century but lost its Victorian appearance early in the 21st century when it was remodeled as a single-family house.

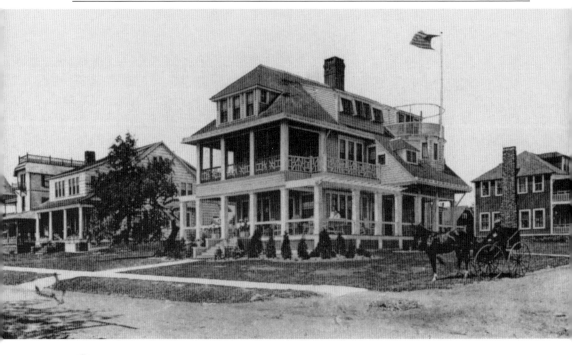

CHAPTER

3

COMMUNITY

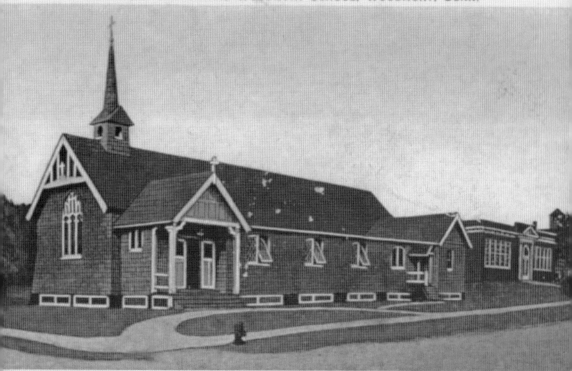

ST. AGNES CHURCH AND WOODMONT SCHOOL, WOODMONT, CONN.

In 1906, St. Mary's Catholic Church on Gulf Street opened St. Agnes Chapel (shown on this 1941 postcard) on Center (Dixon) Street for the summer parishioners in Woodmont. It was winterized in 1951 to become year-round, but when St. Agnes Church opened on Merwin Avenue in 1960, the chapel was torn down for an addition and a parking lot for the Woodmont School next door.

33

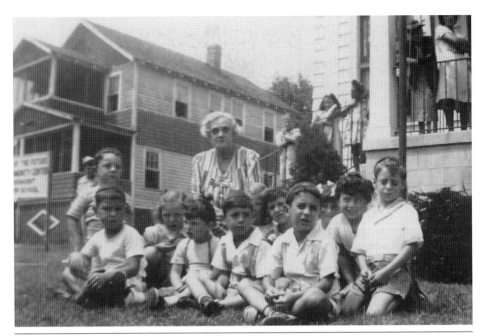

The Hebrew Congregation of Woodmont opened at 15 Edgefield Avenue in 1927 to serve the Jewish families who summered in the tri-beach area. The small synagogue was open until an electrical fire in 2012; it was demolished in 2022. The social hall next door, built in 1947, now serves as the synagogue. Sunday school teacher Anna P. Max poses with her class in front of the synagogue in 1945; next door is a sign announcing the future home of the social hall. (Past image, courtesy Sonya Goldberg.)

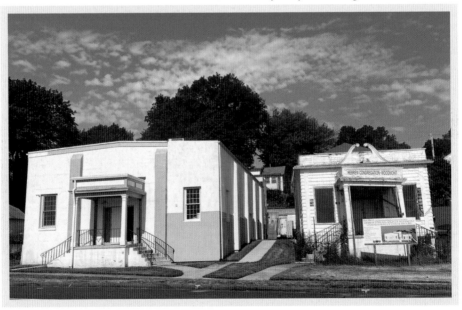

COMMUNITY

Georgeanna (Woolsey) Bacon of New Haven donated Playridge, her summer home on Merwin's Beach (shown here around 1916), to the Connecticut Children's Aid Society in 1901. Each summer, the Playridge Home for Crippled Children, as it was known then, gave over 500 children the chance to enjoy fresh air, salt water, and fun for day visits and vacation stays. Later, the three-story gambrel-roofed cottage at 99 Merwin Avenue served underprivileged children. Today, there are two homes there, built in 1995.

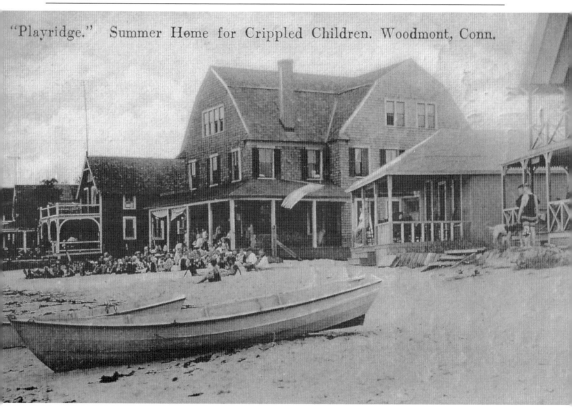

"Playridge." Summer Home for Crippled Children. Woodmont, Conn.

Built around 1880, the one-room Burwell's Farms schoolhouse taught generations of Woodmont students. The most well-known teacher was Fannie Beach (1867–1967), whose family had a large farm on Merwin Avenue, then called Maple Street. Today, it is an 886-square-foot, four-room private home across the street from East Shore Middle School (formerly Seabreeze School) at 233 Chapel Street. When built, the school was surrounded by farmland; today, the house is nearly obscured with trees, shrubs, and wild bamboo. (Past image, courtesy Joseph Holt Collection.)

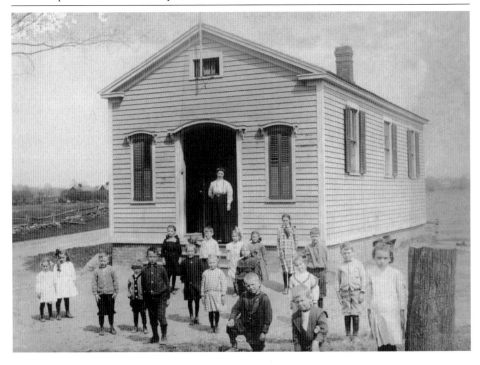

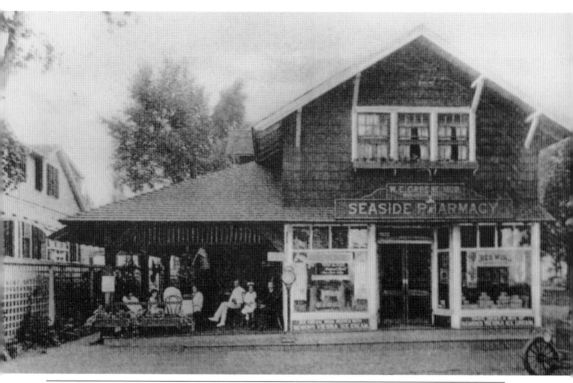

According to a 1900 advertisement, Lowe's Seaside Pharmacy (shown in this 1926 postcard), at 12 Cherry Street (Village Road), offered "pure drugs, stationery, toilet articles, Woodmont souvenirs, Pain's Manhattan fireworks," and an outdoor eating pavilion. During the 1940s and 1950s, William "Doc" Nolan was the pharmacist, and he was also the warden of Woodmont from 1944 to 1956. Nate Barron was the last pharmacist before the pharmacy moved to Point Beach. To the left of the pharmacy was the Woodmont Inn, now a private home.

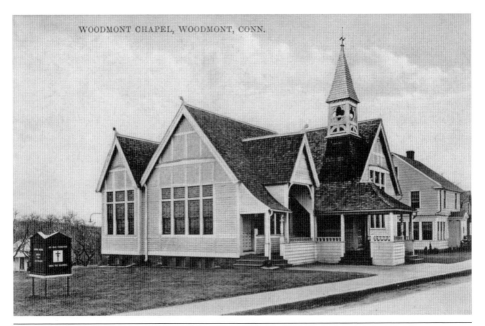

WOODMONT CHAPEL, WOODMONT, CONN.

Milford was founded by men and women seeking religious freedom, and the first community building in Woodmont was a church. Organized on May 5, 1885, the Woodmont Union Ecclesiastical Society initially met at the Burwell's Farms one-room schoolhouse. On land donated by local farmers Mortimer Treat and the Bryan family, the nondenominational Woodmont Chapel opened in 1887 at the corner of what was then Main Street and Maple Avenue (now Chapel and Merwin). Today, it is the Evening Star Holiness Church. (Past image, courtesy George Peacock.)

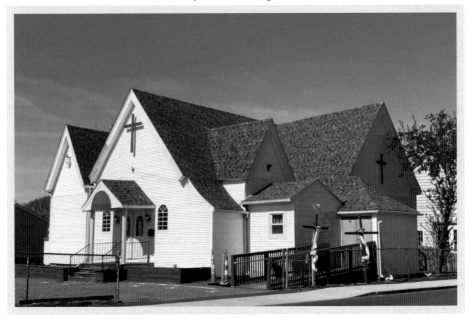

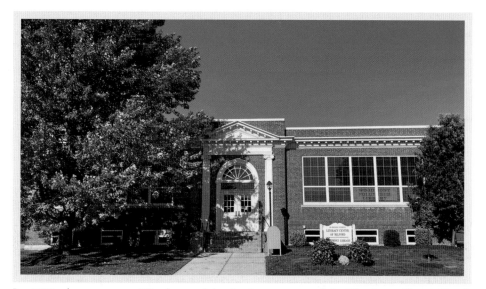

In 1918, the two-room Woodmont School was built at 16 Dixon Street, replacing the 1880 Burwell's Farms schoolhouse on Chapel Street. Two rooms were added by 1927, and a two-room portable school addition was built after World War II, remaining in place until 1952 when Seabreeze School opened. In 1970, it was renamed the Woodmont/Fannie Beach School to honor its most well-known teacher. The school closed in 1979, and today, it houses the Woodmont Library, a day care, and other community services. (Past image, courtesy Lowell Beach Sykes.)

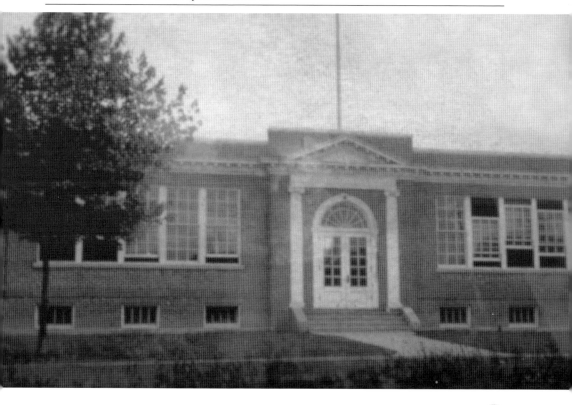

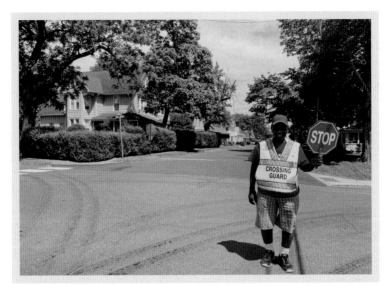

For several years, John Void has kept children safe walking to and from school at the intersection of Chapel Street and Kings Highway, just like officer John Sullivan did at the same corner in 1915. Woodmont has been the home to three schools—the one-room schoolhouse (1880) at the intersection of Chapel Street and New Haven Avenue, the Woodmont School on Dixon Street (1918), and the Seabreeze School (1952), which became East Shore Middle School (1991). (Past image, courtesy Cable Postcard Collection.)

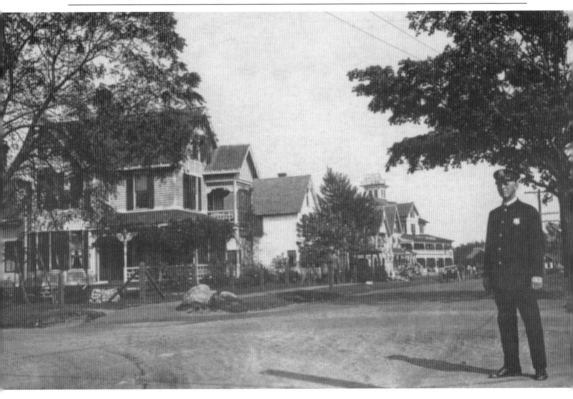

COMMUNITY

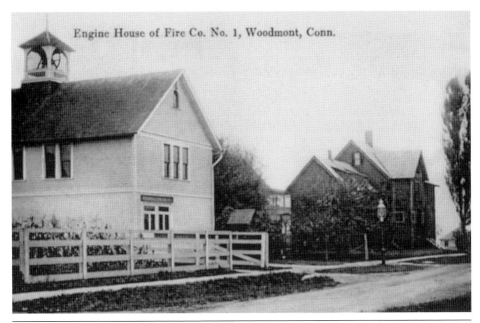

Engine House of Fire Co. No. 1, Woodmont, Conn.

When Woodmont became a borough in 1903, the Woodmont Fire Company let borough officials hold meetings in the firehouse, a converted barn on Dixon Street. In 1949, the fire company moved to a new brick firehouse at 128 Kings Highway. After the old barn was torn down in the 1950s, the borough hall relocated to Clinton Street using the two "portable" classrooms from the Woodmont School. In 2017, after Milford closed the brick firehouse, the borough acquired it for the borough hall. (Past image, courtesy George Peacock.)

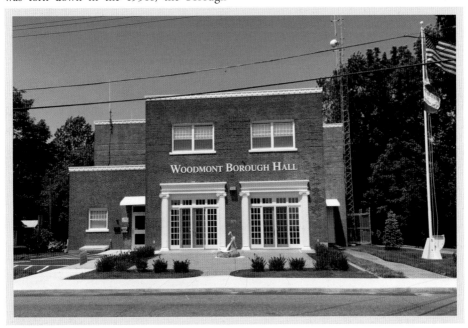

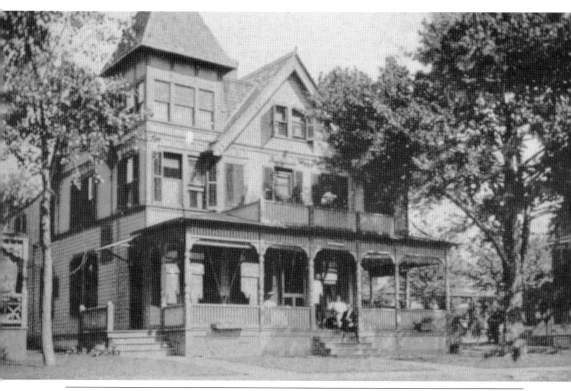

In the late 1800s, the property at 60 Hawley Avenue was a guesthouse called the Bradley Bluff Hotel, but in 1907, Dr. Robert Peck leased it and converted it into a private mental health hospital. For almost 40 years, the Peck Sanatorium served as a rest resort for the treatment of nervous disorders. It became the Woodmont Hall Sanatorium in 1939, the Woodmont Hall Convalescent Home in 1942, and the Woodmont Hall Apartments in 1945. It is a 12-unit apartment building today. (Past image, courtesy George Peacock.)

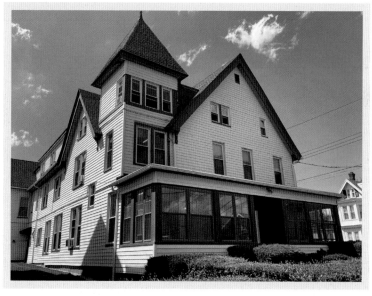

COMMUNITY

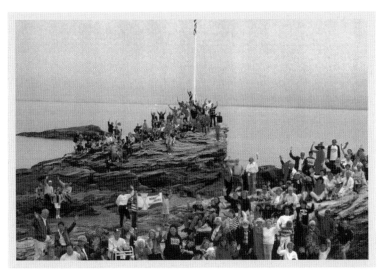

The tri-beach neighborhood used to celebrate summer with an annual Illumination Night, and the borough has hosted Woodmont Day since the early 1900s, when it was held near Signal Rock. A depression and two world wars ended the festivities for many years, but in 1963, Joan (Malloy) Miller brought back Woodmont Day at the Hawley Avenue playground. In 2003, on the 100th anniversary of the borough of Woodmont, the Woodmont Day Committee reenacted a favorite photograph taken on Woodmont Day in 1911. (Present image, courtesy Joseph Holt Collection.)

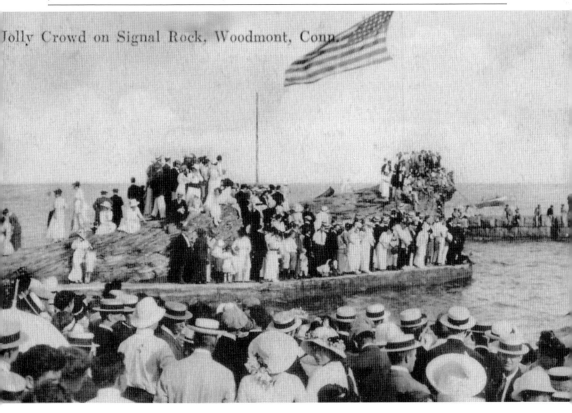

Jolly Crowd on Signal Rock, Woodmont, Conn.

The Hawley Avenue playground—officially Trubee Doolittle Park—used to be called Howard Park. In 1945, it was deeded to the City of Milford for $1 by Esther Vincent of Meriden, Connecticut, and Helen McConky of New Rochelle, New York. The top portion, now a basketball court, had been used for decades as tennis courts by Olin Clark's two Bonsilene hotels. Clark designed the park in the 1880s, and the city has maintained it for recreational use since 1945. (Past image, courtesy Joseph Holt Collection.)

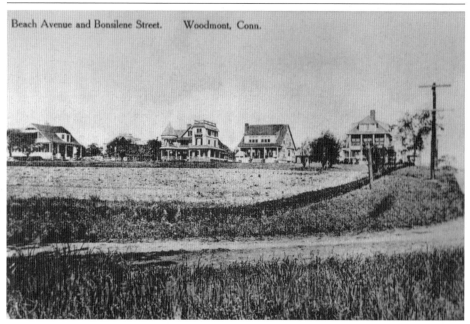

Beach Avenue and Bonsilene Street. Woodmont, Conn.

COTTAGES
AND HOMES

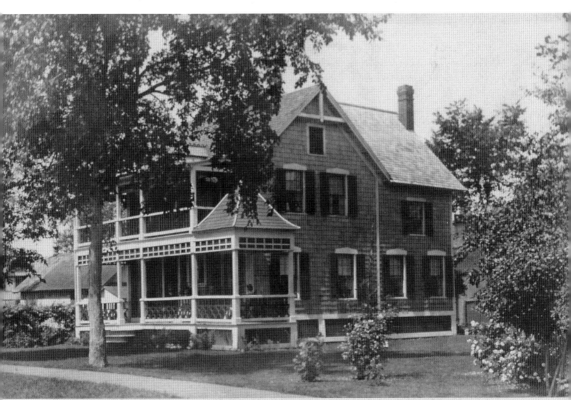

Louise (Coe) Plumb, who owned the cottage shown on this postcard, addressed it to her nephew Master Howard E. Coe around 1910, writing, "Ask your father if he will not take you and Mother to the cottage sometime." In 1980, a much-older Howard added a note to the back of the postcard saying the cottage was inherited by Howard's uncle John Allen Coe.

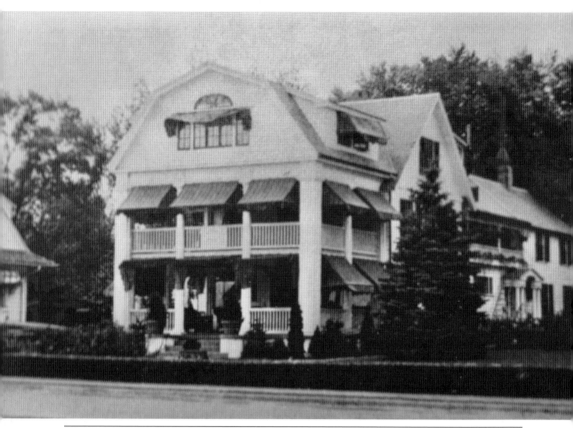

Frederick Blackall originally owned this stately 1894 cottage at Crescent Beach, and it has retained its charm for over a century. According to the September 19, 1912, issue of the *Bridgeport Evening Farmer*, a fire broke out around 7:30 p.m. shortly before his daughter Dorothy was about to be married in the house. Quick action by the Woodmont Fire Company saved the house at 124 Beach Avenue from destruction by extinguishing the blaze in the floorboards. The bride and wedding guests "were not let in on the secret" until after the wedding. (Past image, courtesy Joseph Holt Collection.)

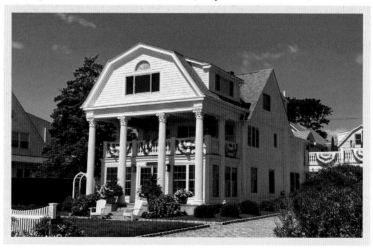

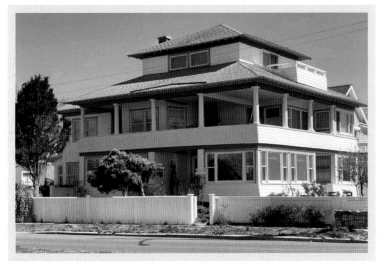

Walter Randall had an elaborate Victorian cottage built around 1900 with a view of both Anchor and Crescent Beaches. Randall served as a Woodmont burgess, and in 1914, a special meeting was held at his cottage to hear a presentation from Sylvester Poli about closing Division and Mark Streets, near his summer residence. Over the years, the house lost its gables and some of its porches, but the view has not changed. Today, it is a two-family house at 132 Beach Avenue.

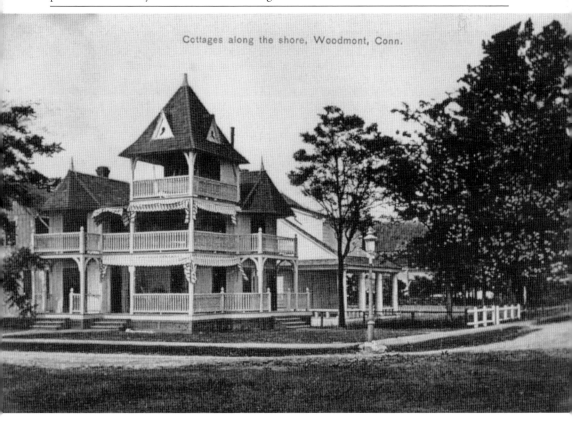

Cottages along the shore, Woodmont, Conn.

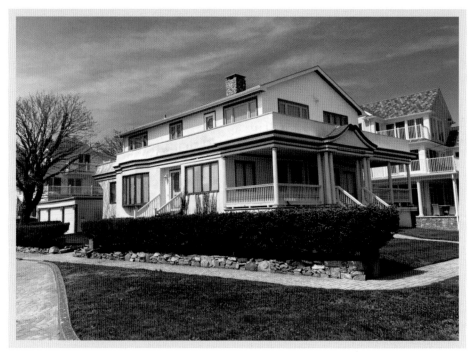

Blakeslee's Cottage was built in 1910 by Charles Wells Blakeslee, who founded a construction business in New Haven in 1844. "It is my creed to build for the future—to build quality and permanence," he said in 1865. He must have known what he was doing, as both his house and his business still exist. Despite a fire in 1965 that destroyed the third floor, his cottage in Woodmont still stands today at 108 Beach Avenue.

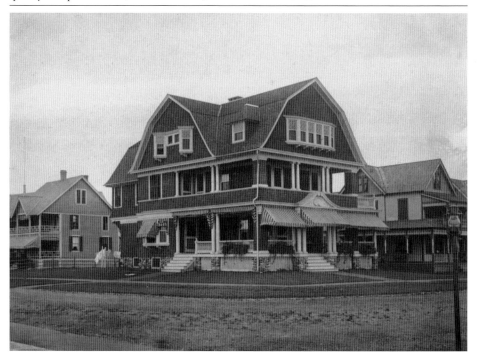

COTTAGES AND HOMES

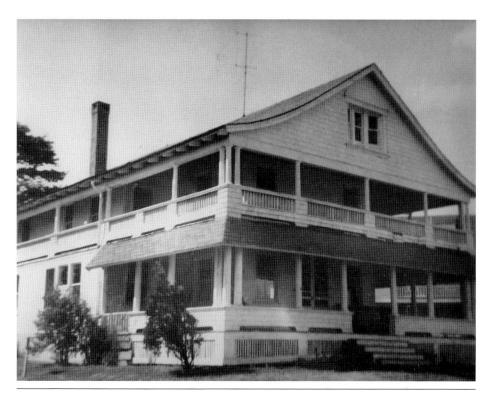

In 1965, shortly after Mary Ellen and Phil Allspaugh got married, they bought a furnished cottage named the Houseboat at 94 Beach Avenue. The house, built in 1896, has been updated but has retained its original looks and charm. They still use the dining room table and marble-topped buffets that came with the house. Now married for 60 years, they have loved the house almost as long as they have loved each other.

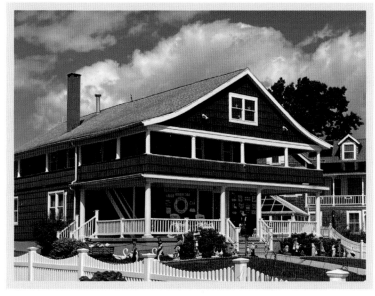

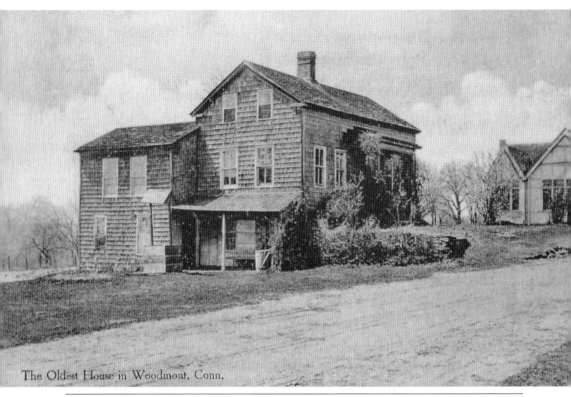

The Oldest House in Woodmont, Conn.

In 1659, two of Milford's original settlers, Alexander Bryan and Robert Treat, acquired the land between Indian River and Oyster River, which included Burwell's, Bryan's, and Merwin's farmland. This is the Bryan House—Woodmont's oldest home—built around 1790 at the intersection of Chapel Street and Merwin Avenue. Today, the house, at 71 Chapel Street, is not very different from the one shown in the 1921 postcard. The current owners cherish the history of the house and work to maintain its historic integrity.

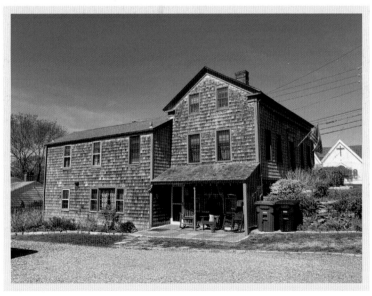

COTTAGES AND HOMES

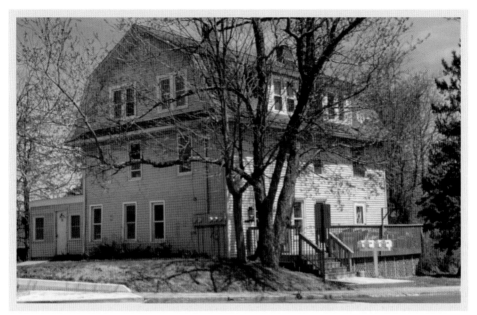

Another Bryan House (pictured around 1921) was built in 1880 at 158 Chapel Street, across from the original Bryan House. Charles Bryan Sr. (1853–1949) likely inherited the dairy farm and one of the houses. He was a founding member of the Woodmont Fire Company (WFC), and two of his sons—Cliff and Charles Jr.—were WFC members. The dairy farm later transitioned to a heating fuel business. By the 1930s, Charles Jr. ran the fuel business and Cliff ran the Woodmont Ice Company.

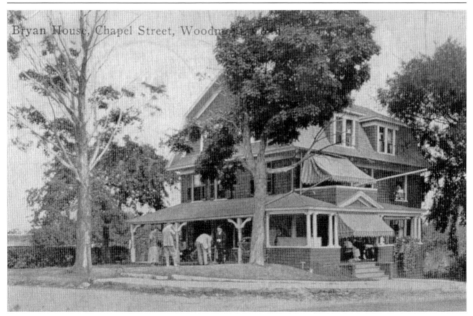

Bryan House, Chapel Street, Woodmont

After renting cottages in Woodmont for several summers, Judge Abraham Markle and his wife, Sylvia, moved to 68 Beach Avenue year-round in 1946 with their daughters Patricia and Marilyn. Sylvia taught third and fourth grades at Woodmont School for many years. Three years later, Sylvia's sister and two of her brothers also moved to the borough. The Markle house, pictured in the 1920s, is still in the family, and four generations have enjoyed the house and its beautiful front porch.

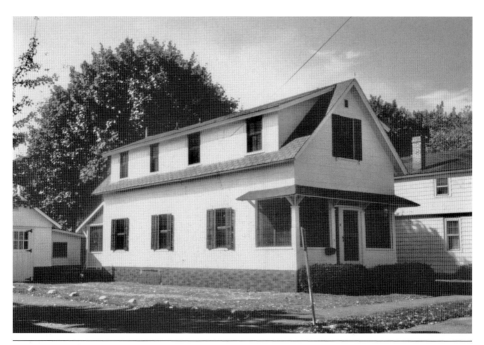

William and Nellie Dunbar built the WillNell Cottage in 1909 on what was then 11 Central Avenue. Their son William spent summers there as a child and later with his wife, Carolyn. Their granddaughter Nancy Dunbar, who spent many summers there, replaced the house in 1994 with an updated, year-round replica. Nancy; her husband, George Peacock; and their son Scott—California residents for decades—still visit the cottage on the street that was renamed Dunbar Road in the 1970s in recognition of her father. (Past image, courtesy Nancy Dunbar.)

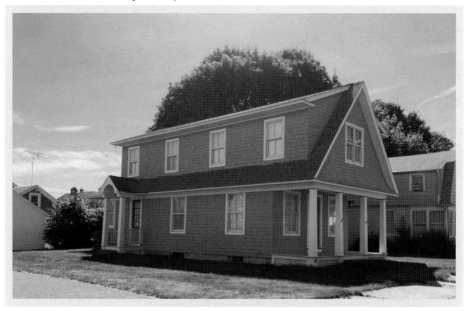

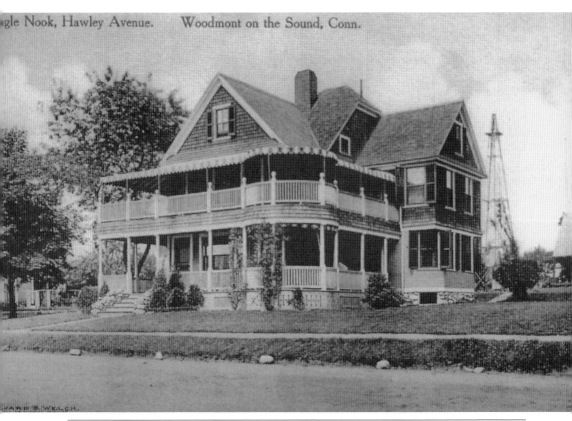

igle Nook, Hawley Avenue. Woodmont on the Sound, Conn.

Shingle Nook Cottage at 50 Hawley Avenue is not one of the more well-known cottages in Woodmont, but it was loved enough to be given a name. Built around 1910, it was probably winterized after World War II. At that time, the need for immediate housing precluded the concept of preservation or restoration, but the beauty of the house remains, despite renovations in the second half of the 20th century. It just misses its porches.

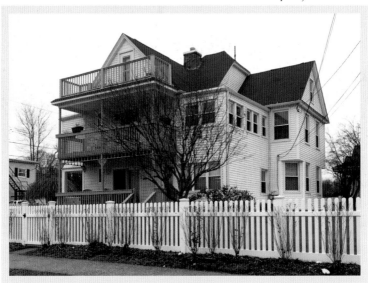

COTTAGES AND HOMES

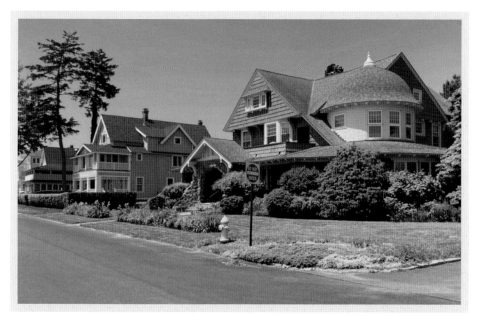

Built in 1910, the fieldstone and clapboard house at 40 Beach Avenue has been owned by the same family since 1927, when Esedor Derecktor, a Russian immigrant, purchased the house from a German immigrant named Charles Niklas, who made his fortune from the brewery business. This photograph was taken in 1924, during Prohibition. Rumrunners who were planning to bootleg illegally invited Niklas to join them, but he declined because he could not betray his adopted country. He lost both his business and his house.

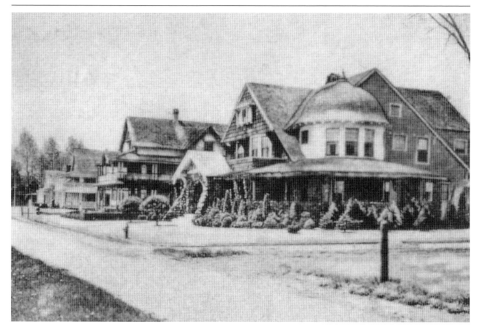

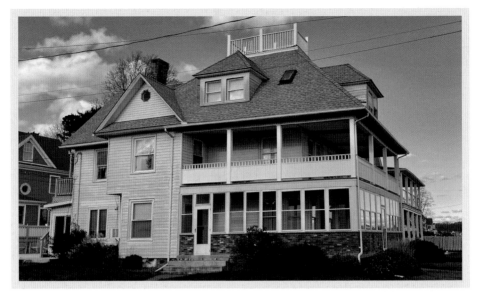

This house at 38 Beach Avenue has been in the same family for more than 60 years. Situated right across the street from the beach, one of its most engaging features is a widow's walk— one of only two in Woodmont. Widow's walks were often found on 19th-century houses along New England's coast, suggesting that mariner's wives would watch for their husband's return, often in vain. Widow's walks are in fact a standard decorative feature of Italian architecture—a variation of a cupola. (Past image, courtesy New Haven Museum.)

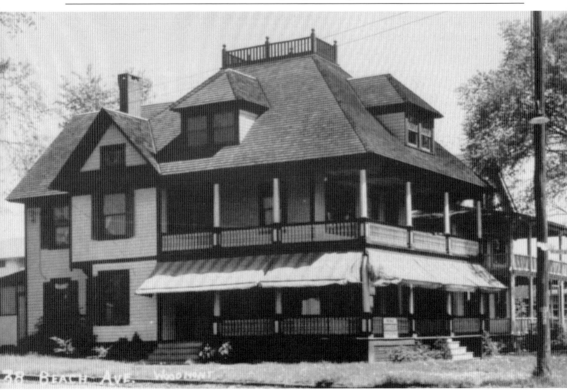

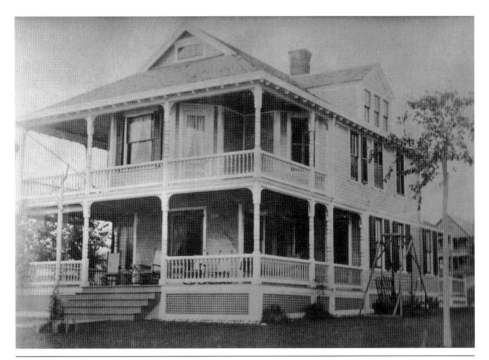

This is a sweet, unassuming cottage on Beach Avenue, uncommon for two reasons: it has a large lot (by Woodmont standards), and it has not lost its identity by over-renovation. It was built around 1903 at the foot of the Hawley Avenue playground. The current owners bought it from Maria Belfonte in 1985, and while they have made a lot of interior changes, adding rooms in the back each time they had another child, they managed to keep its essential character. (Past image, courtesy Joseph Holt Collection.)

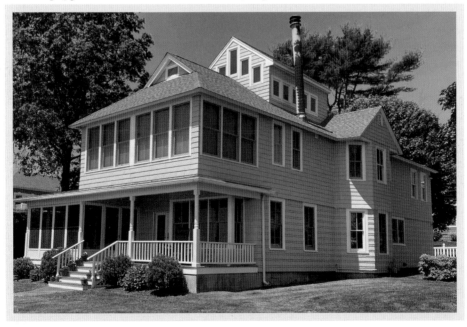

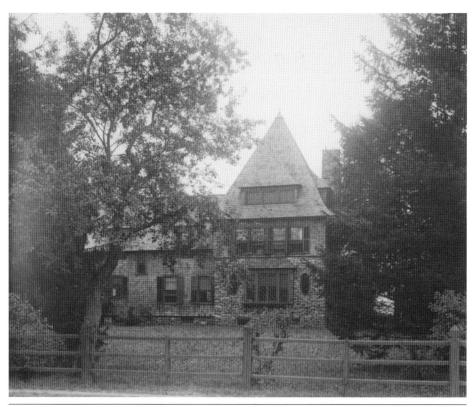

Joseph Anderson, a Congregational pastor from Waterbury, built Rosemary Cottage, the first beach cottage in Woodmont near Oyster River in the summer of 1874, according to the September 1, 1906, issue of the New Haven weekly newspaper *Saturday Chronicle*.

Reverend Anderson liked Woodmont so much that he then built Anderson Towers, this massive, year-round Victorian house on his property near the cottage. Between 1904 and 1909, he was the second warden of the borough. He died in Woodmont in 1916.

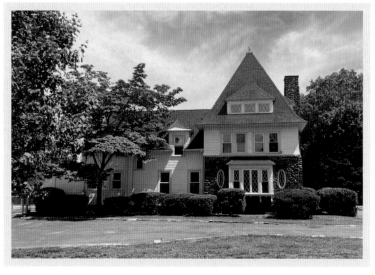

COTTAGES AND HOMES

CHAPTER 5

LOCAL BUSINESSES

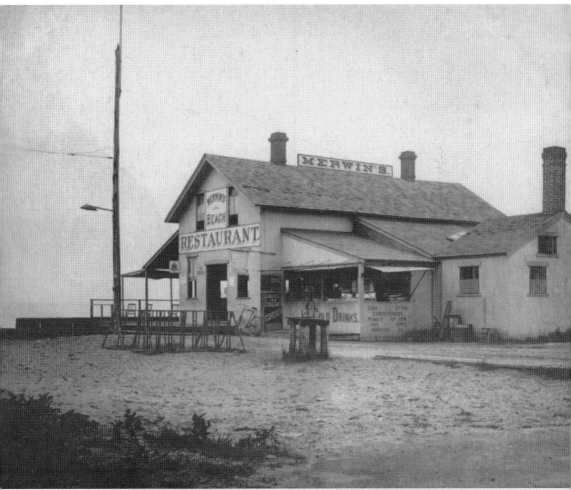

William Merwin, a retired New Haven policeman, ran the Merwin's Beach Restaurant from about 1888 until his death in 1900. Around 1905, his son Hardy moved the restaurant back on the property, and it became the kitchen for Merwin's Inn, a new hotel built in front. In 1922, Sylvester Poli bought the inn and converted it into the largest of his "cottages."

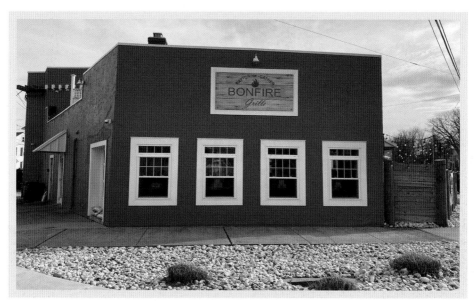

Built around 1915, Sloppy Joe's was owned by Joe Soloway and Frank Kellert. It was the most popular restaurant in Woodmont during the heyday of "Bagel Beach"—between World War I throughout the 1950s. When the neighborhood transitioned from a summer to a year-round community, Jimmy and Lowell Loomer bought Sloppy Joe's, and—displaying both humor and appreciation for the restaurant's long history—reopened it as Sloppy José's, a Mexican restaurant. Today, it is enjoying new life as the Bonfire Grill.

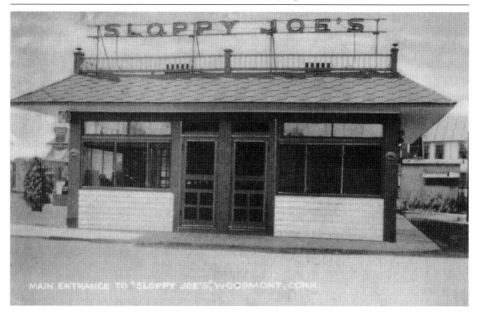

MAIN ENTRANCE TO "SLOPPY JOE'S", WOODMONT, CONN.

LOCAL BUSINESSES

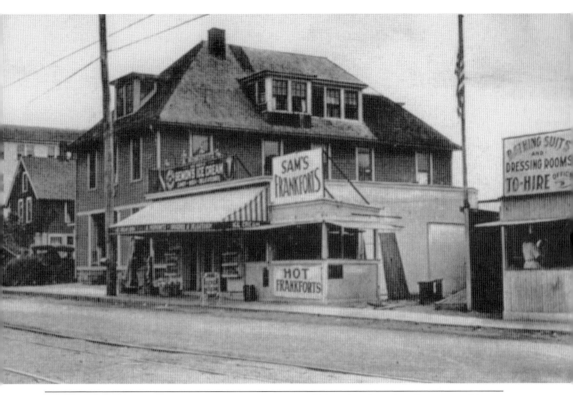

The small commercial center of Merwin's Beach clustered around the intersection of Hillside and Merwin Avenues. Numerous businesses have opened, changed hands, and eventually closed, including, in this 1935 photograph, Moscovitz groceries and delicatessen, Sam's Frankforts stand, and a small booth where beachgoers could rent bathing suits. Now, it is home to the Villa D'Oro condominiums. The large building next to the deli was once the Lilu Hotel, which became apartments before being demolished in 1999. Behind that is the Hotel Sauter. (Past image, courtesy Andy Blair.)

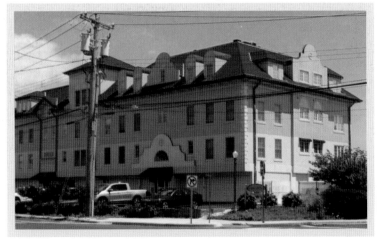

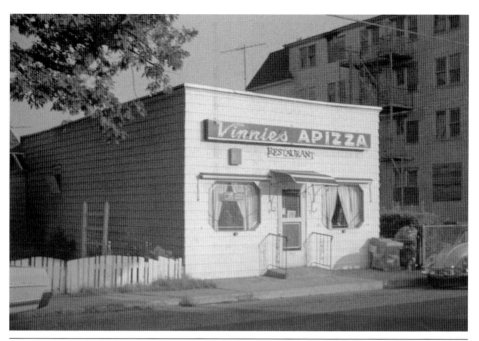

Pizza in Connecticut is often called "A-beets" with an Italian pronunciation, particularly around New Haven, one of the first places to make and perfect pizza in the United States. Vinnie's Apizza, next to the old Hotel Sauter, was up there with the best during the 1960s and 1970s. Patrons still rave about the pizza and remember the Statesman jukebox. Today, it is a 3,000-square-foot beachfront home at 31 Merwin Avenue, built in 1965 by Joseph Leto, who bought the property from Vincent Velleco. (Past image, courtesy Andy Blair.)

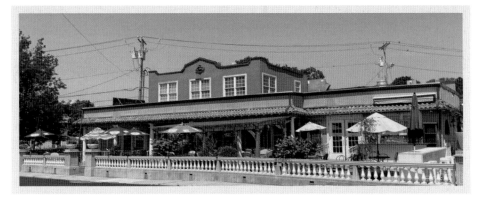

In 1927, theater owner Sylvester Z. Poli had a new trolley station built near his summer home in Woodmont. But by 1937, Woodmont trolleys were abandoned. In 1949, a Poli nephew, Thomas Poli Nolan, transformed the retired Villa Rosa trolley station into Tom's Villa Rosa Restaurant. For nearly 70 years, the building at 141 Merwin Avenue has housed different restaurants—most recently, the Village Bistro at the Beach House. (Past image, courtesy Walter Poli Sheahan.)

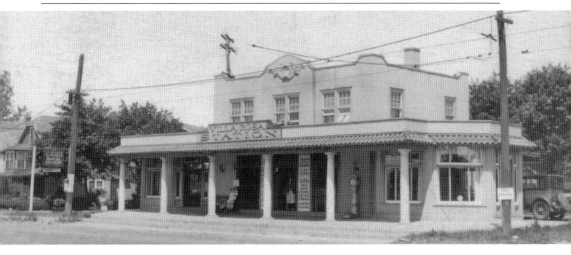

By the late 1930s, the automobile had replaced the trolley. Ironically, the Hyperion Garage, owned by Frank Vordersock, opened right next to the old Villa Rosa trolley station, which had closed in 1937. The garage parked, washed, and repaired cars; sold Socony gasoline; offered crankcase service and oil changes; and repaired and replaced tires. Gas was 22¢ a gallon. Today, the property is the MillWood Apartments, at 141 Merwin Avenue, alongside the trolley-station-turned-restaurant at the triangular intersection of Merwin Avenue and Abigail Street. (Past image, courtesy Walter Poli Sheahan.)

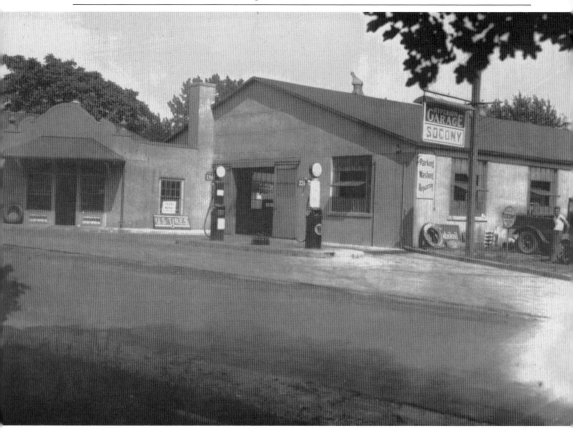

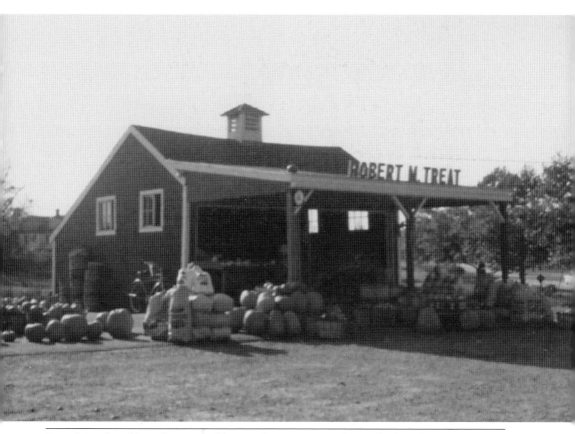

In 1948, Robert Treat, known as "the Bear," started the Robert M. Treat farm as a family business. He hooked up a farm stand to his tractor, pulled it to the side of the road, and began selling fruits and vegetables. In the 75 years since then, "the farm has evolved," said Mary Treat, whose brother Robert Wagner handled the construction of a new post-and-beam barn in 2008. "My father-in-law used to say, 'We are just stewards of the land.'"

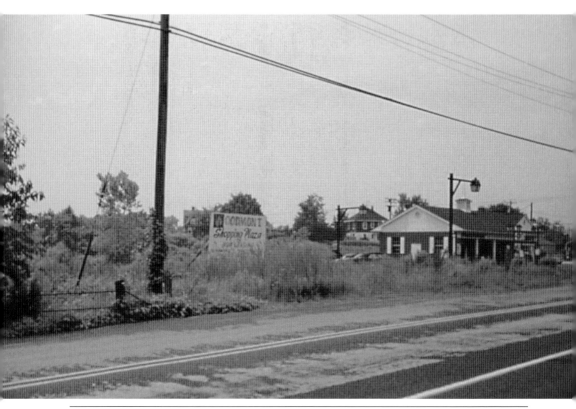

While the 1970s was not the distant past, it was a decade of growth that forever changed neighborhoods. This 1973 photograph shows an Atlantic Richfield (ARCO) gas station on New Haven Avenue, with the surrounding land for sale to develop a shopping plaza. The land was part of the Bryan family farm, a produce/dairy farm established in 1866, but after small dairy farms declined locally, this was the coal yard for Charles Bryan Sr., who transitioned to heating fuel (coal and firewood). (Past image, courtesy Andy Blair.)

LOCAL BUSINESSES

Built in the early 1900s, the Anchor restaurant was across the street from Anchor Beach. Before it closed in the late 1960s, it was renamed Sandy's Anchor restaurant by then owner Jack Diamond for his daughter. Even today, former customers remember the screened porch, sand on the floor, the smell of fried food, Coppertone, cigarettes, and salt air, with transistor radios tuned to WAVZ or WNHC in the background. The big attraction was a pinball machine. Today, 140 Beach Avenue houses two apartments.

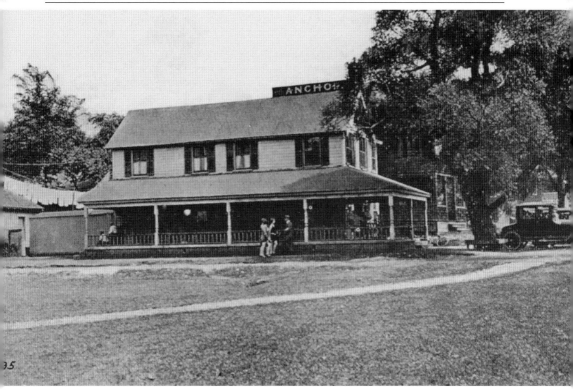

Tobak's Coffee Pot Lunch was a luncheonette on the corner of Village Road and Kings Highway. Owned by M. and V. Tobak, the restaurant was famous for its hamburgers, French fries, steak sandwiches, and Horton's ice cream, which may well have been the J.M. Horton Ice Cream Company of New York City, once the largest ice-cream manufacturer in the world from the 1890s to the 1930s, when it was bought by Borden. Today, a small park has replaced Tobak's.

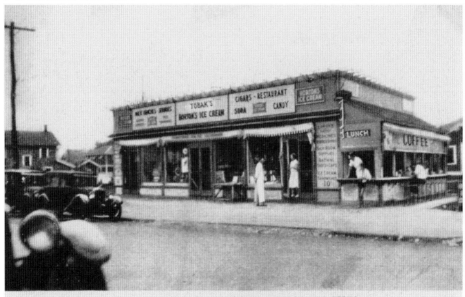

TOBAK'S COFFEE POT LUNCH, WOODMONT, CONN.

LOCAL BUSINESSES

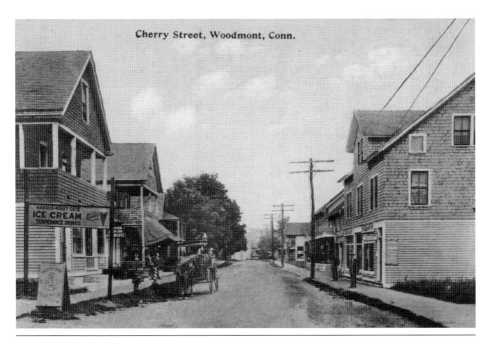

Cherry Street, Woodmont, Conn.

Cherry Street (Village Road) was once "downtown" Woodmont, but nothing commercial remains today. This view, looking toward the water, shows Susman's department store on the right and a store selling ice cream and temperance drinks (soda) on the left. Cherry Street once was home to a grocery store; bicycle shop; two tinning, plumbing, and gas-fitting businesses; a hardware store; a post and telegraph office; a barbershop; two hair salons; a liquor store; a restaurant; a bakery; a candy store; and a fish market. (Past image, courtesy George Peacock.)

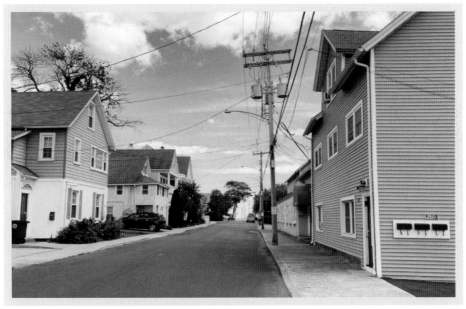

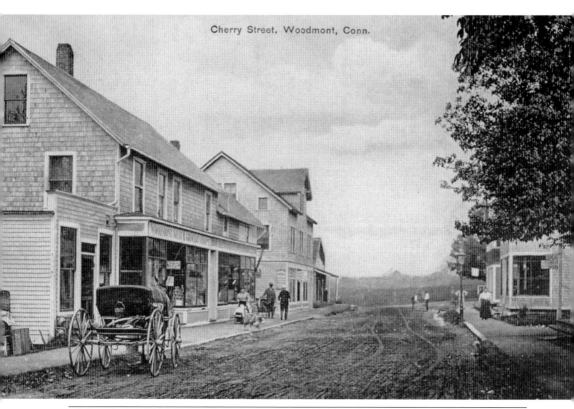
Cherry Street, Woodmont, Conn.

The longest-lasting business on Village Road was Scribner's Restaurant, which opened on April 6, 1973, and closed after a fire on October 31, 2018. In the days of old, the left side of Scribner's was once the Woodmont Meat and Grocery (which later became Petersen's, then Frederick's markets). The right side was Hall's plumbing, which later became Clark-Hall Hardware. The community still grieves for Scribner's, which was a gathering place for countless customers for nearly half a century. (Present image, courtesy Michael Clark.)

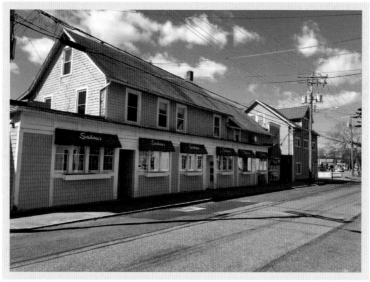

LOCAL BUSINESSES

Tearooms—serving tea, coffee, soft drinks, and light refreshments—surfaced during the temperance movement but their popularity peaked during Prohibition (1920–1933). The Village Lunch and Tea Room, at 113 Hawley Avenue, later housed the Woodmont Library, open from 1945 to 1966, when it moved to the Woodmont Chapel. In 1980, it became an all-volunteer library in the old Woodmont School after the city closed its branch libraries. The old tearoom-turned-library was torn down, and condominiums were built in 1983.

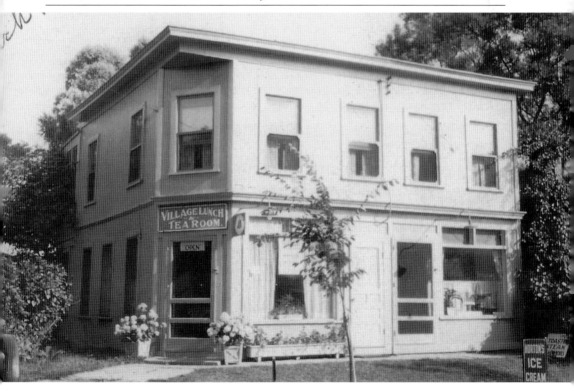

Ernestine and George Kittle ran the Kittle Shop at the corner of Hawley and Anderson Avenues from the 1930s to the 1950s. Today a garage, it had once been a tearoom, serving light refreshments. By the 1940s, the Kittle Shop was a mini-grocery store, selling milk, juice, baby food, newspapers, and daily necessities. Soda was kept cold in an old oak icebox, and George nailed the soda bottle caps to the ceiling of the shop in the shape of a huge star. (Past image, courtesy Toni Lee Moldenhauer.)

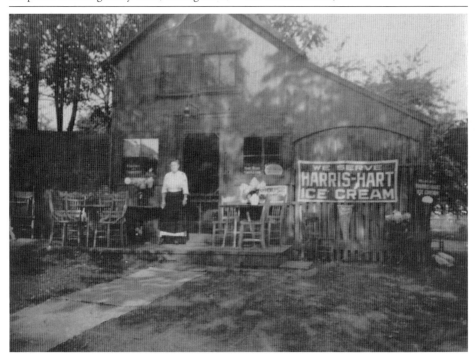

LOCAL BUSINESSES

CHAPTER 6

MEMORABLE SCENES

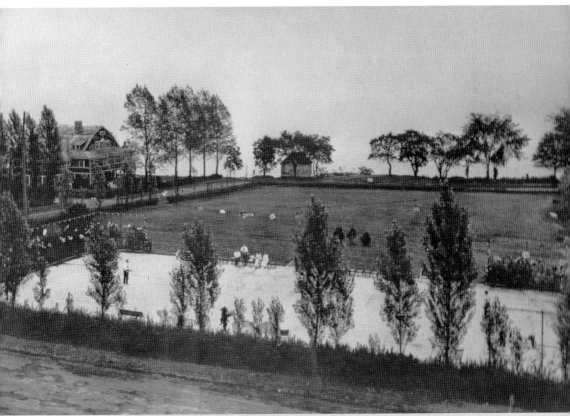

Woodmont had three sets of tennis courts, including this one by the Bonsilene Hotel at the Hawley Avenue park (now a basketball court). The Woodmont Country Club had tennis courts across New Haven Avenue, and the Pembroke had courts at the corner of Hawley Avenue and Dixon Street. Woodmont also had a golf course near the Anderson Avenue trolley station. (Courtesy Joseph Holt Collection.)

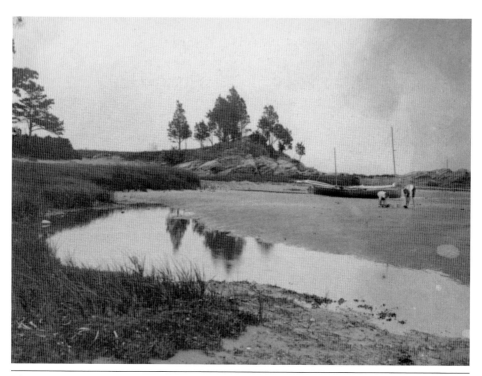

This promontory, just west of Merwin's Point, was sometimes called Lazy Rock. Around 1910, Sylvester Z. Poli, an immigrant who became a famous theater owner, acquired the rocky piece of land, along with three-and-a-half surrounding acres, where he built a lavish family compound over the next 20 years. In cooperation with the borough, Poli agreed to include a public right-of-way for beach access next to the property. Today, the promontory is called Poli's Point.

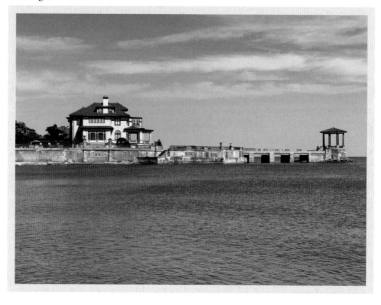

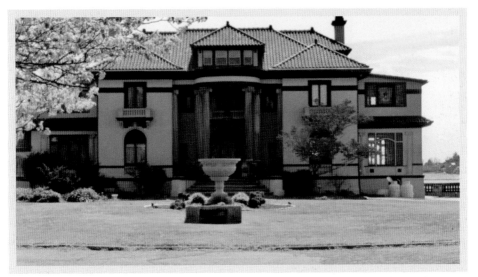

Between 1910 and 1913, Sylvester Z. Poli built this Mediterranean mansion named the Villa Rosa for his wife. The 15-room summer residence was constructed of stone and marble in the Italian country style, and Poli designed much of the decor himself with art imported from Italy. Poli, a wax sculptor who came to the United States in 1881 at the age of 23, established the Poli Theaters, a chain of 28 vaudeville and movie theaters, which he operated between 1893 and 1928. (Past image, courtesy Joseph Holt Collection.)

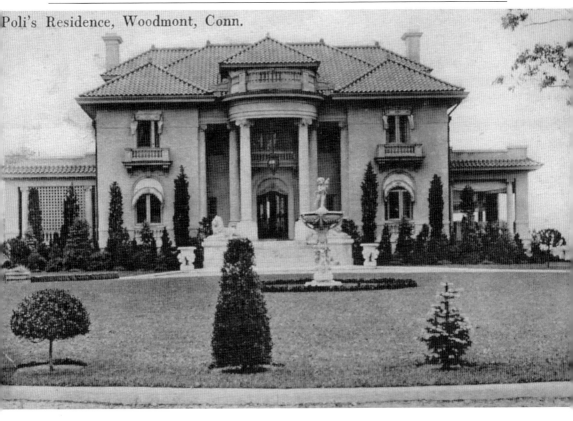

Poli's Residence, Woodmont, Conn.

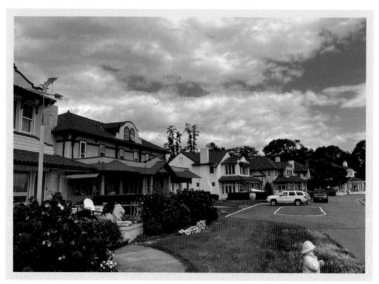

After the Villa Rosa was completed, Poli turned his attention to creating the Villa Rosa Terrace—10 new "cottages" for his children and visiting family members. In 1922, he converted the old Merwin's Inn to the largest cottage, a duplex home. He also acquired the old Sound View Hotel, right next to Merwin's Inn, where he built three more cottages between 1926 and 1928. The others were built on his property, including two non-waterfront cottages completed in 1929.

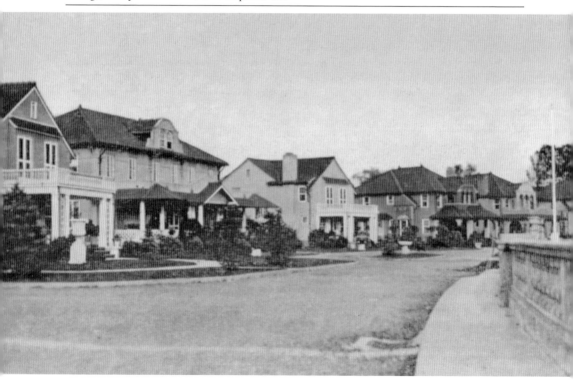

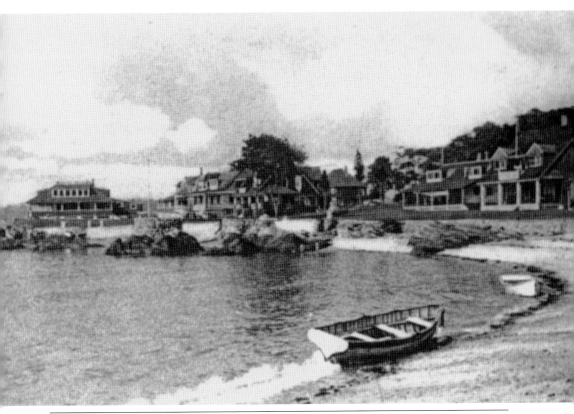

Merwin's Point, shown here around 1907, was the site of one of Woodmont's first summer cottages, built in 1874 by Charles and Angelina Perkins of Waterbury. Around 1899, the property was sold to Werton W. Walker, and for a while, it was called Walker's Point.

In the 1920s, it was briefly called Sweezy's Point after owners Jerome and Mary Sweezy. Despite the various attempts to rename the point after the current owners, today the area is still called Merwin's Point.

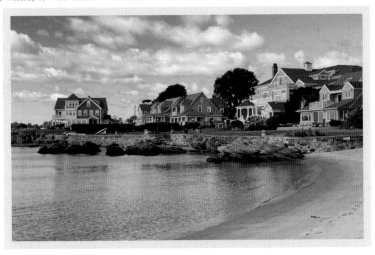

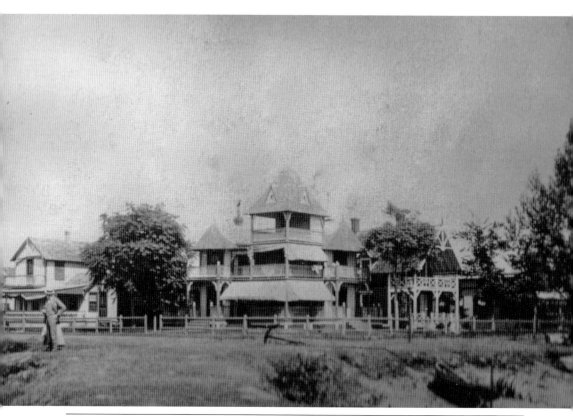

Woodmont is full of "points," and Randall's Point is one of the nicest, situated directly across the street from Signal Rock. This point divides Anchor Beach and Crescent Beach, offering magnificent views of both beaches and beyond. A small lawn in front of the property has remained untouched for years, allowing people to enjoy the scenes. Around the turn of the 20th century, Randall's Point was the location of the annual Water Carnival, also known as Woodmont Day.

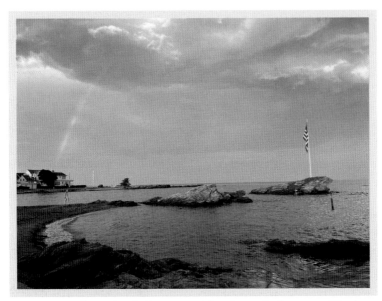

Blakeslee's Point, at the end of Crescent Beach, looks on Signal Rock, which has had a flagpole on it for at least 125 years. Blakeslee's cottage, at left, was built in 1910 by construction giant Charles Blakeslee. Most of his six sons joined the family business except Theodore, who became a Woodmont burgess in 1913. A fire about 60 years ago permanently reduced the house from three to two stories, and the current stucco exterior renders the house nearly unrecognizable.

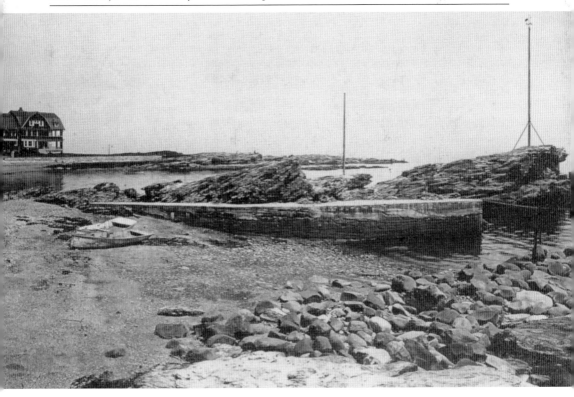

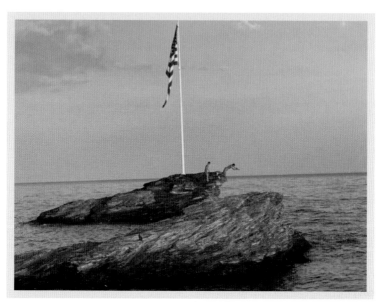

Signal Rock is the definitive icon of Woodmont. Going back to the late 1800s, the flagpole was once used to mark the boundaries for oystermen. The granite pier, seen in this 1912 photograph, was damaged by the Great Hurricane of 1938 and destroyed by Hurricanes Carol and Diane in 1954 and 1955, but the toppled granite stones are visible at low tide. Jumping off Signal Rock at hide tide has been a rite of passage for girls and boys for generations.

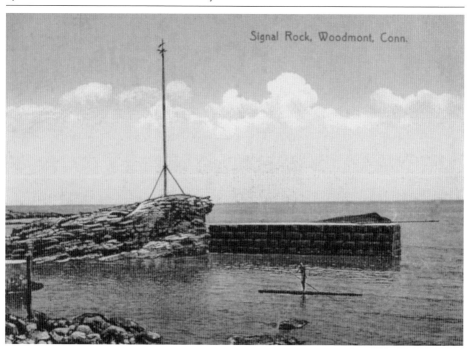

Signal Rock, Woodmont, Conn.

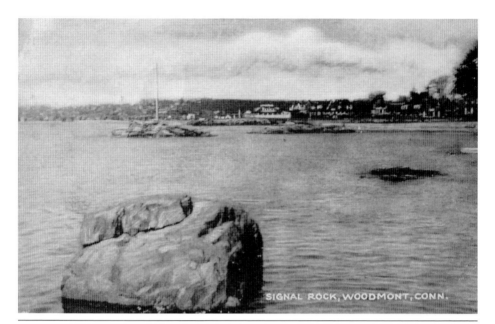

SIGNAL ROCK, WOODMONT, CONN.

Potato Rock sits on the eastern edge of Crescent Beach. An outlier among the gray shale rock formations along Woodmont's coast, this erratic boulder has a distinctive russet color not native to the area. It was likely deposited by the glaciers that created Long Island at the end of the Ice Age. In 1957, during Woodmont's first dredging project to restore sand to the beaches, most of Potato Rock was covered with sand. Not to worry—nature had its way.

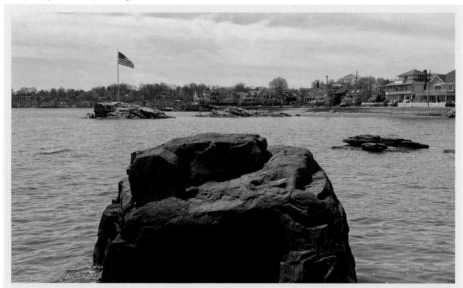

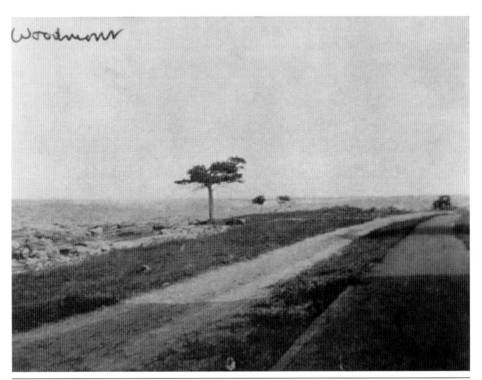

Just east of Potato Rock, the Umbrella Tree, pictured around 1906, crouches over the rocks by Beach Avenue. The original Umbrella Tree was a cedar of Lebanon—a low, scruffy pine with spreading horizontal branches, native to the eastern Mediterranean mountains. It succumbed to a hurricane in the 1950s and was replaced by longtime Woodmont resident Noyes "Stubby" Hall, who planted a Japanese black pine. The "new" Umbrella Tree has lasted more than 50 years but is showing its age.

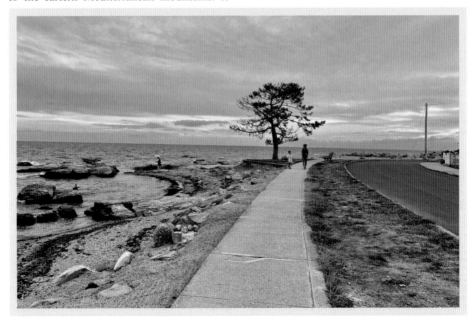

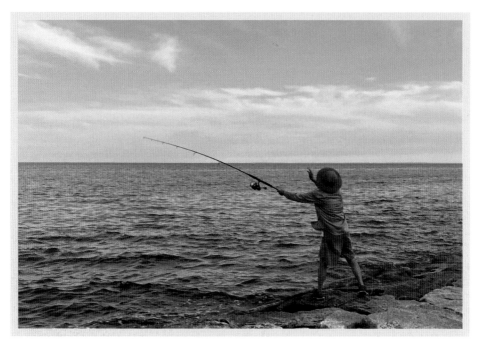

Fishing remains as popular in the 21st century as it was in the 19th and 20th centuries. People, past and present, fished off the beach, the rocks, the groins, and boats, catching blackfish, mackerel, striped bass, and snapper blues, among others. Albert Einstein, who reportedly loved to fish, came to Woodmont for several summers and stayed in the Woodmont Lodge. The late John Volk, a grandson of Fred and Molly Volk, proprietors of the Woodmont Lodge, said his grandfather told him Einstein loved the way he cooked mackerel.

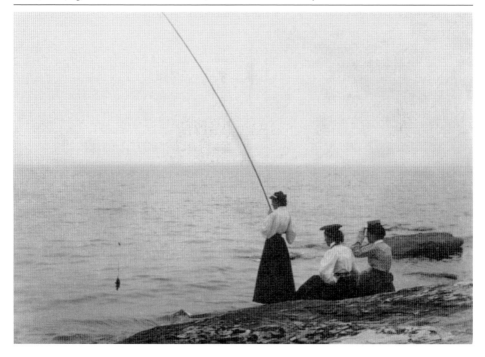

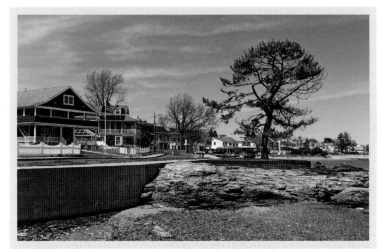

In a time of short-lived trends and rapid change, buildings and landmarks that survive for a century are rare. These two cottages and the Umbrella Tree bring a certain comfort in constancy. Around 1920, Harriet addressed this postcard to Nelly Moore, writing, "This tree on the card, they say here, was brought over from Jerusalem, and is the only one in America." The Umbrella Tree has been a favorite spot for marriage proposals for generations, a tradition that continues to this day.

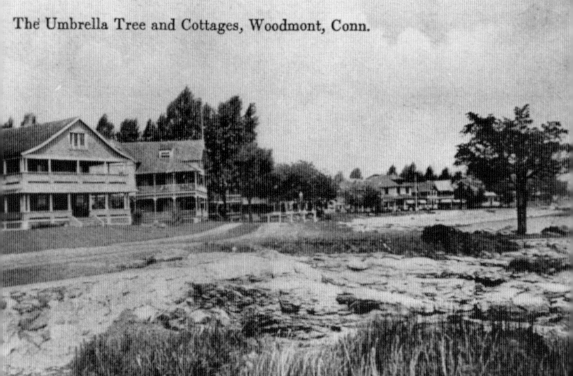

The Umbrella Tree and Cottages, Woodmont, Conn.

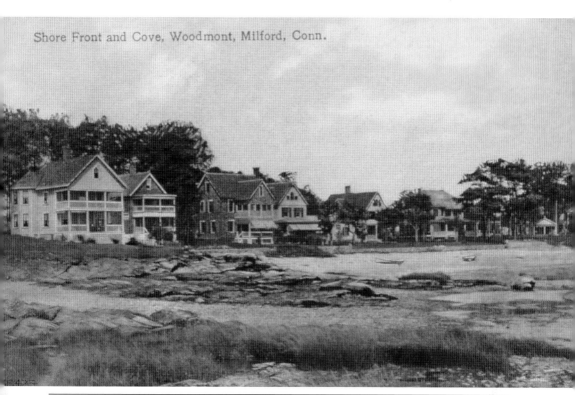

Shore Front and Cove, Woodmont, Milford, Conn.

Some of the earliest "cottagers" built homes right on the beach, as was the case between Chapel and Clinton Streets, around 1912. Erosion proved to be a force they had not anticipated, and they appealed to the borough, which built a concrete seawall. In 1974, residents filed a lawsuit against the borough to restrict the public from using the seawall as a sidewalk. The court ruled in favor of the homeowners, and the seawall has been off-limits since then.

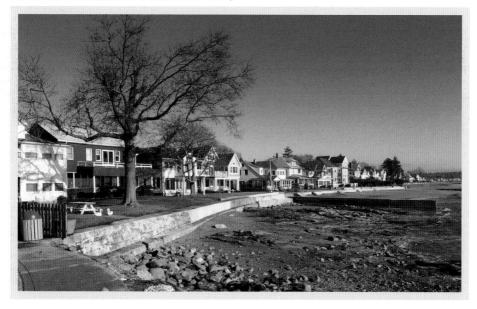

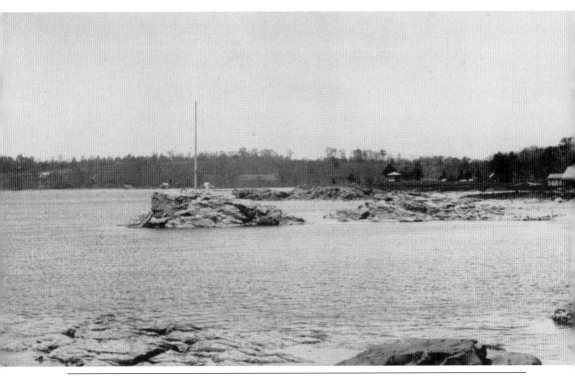

The Signal Rock flagpole fell into disrepair in the late 1940s and remained unused until 1976, when Woodmont restored it for the bicentennial celebration. But in 2019, the 130-year-old pole was deemed unsafe due to extensive wood rot. Erecting a new pole on a rock in Long Island Sound was a challenge, but in 2020, the old pole came down and a new one went up. Very few people have seen Signal Rock without a flagpole. The past image was captured in 1896, while the new photograph, without a flagpole, was taken on March 2, 2020.

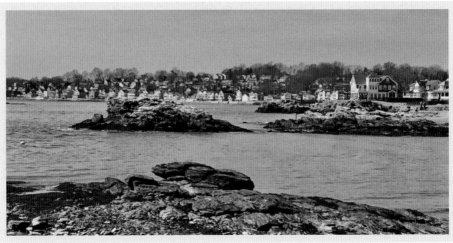

MEMORABLE SCENES

LOST LANDMARKS

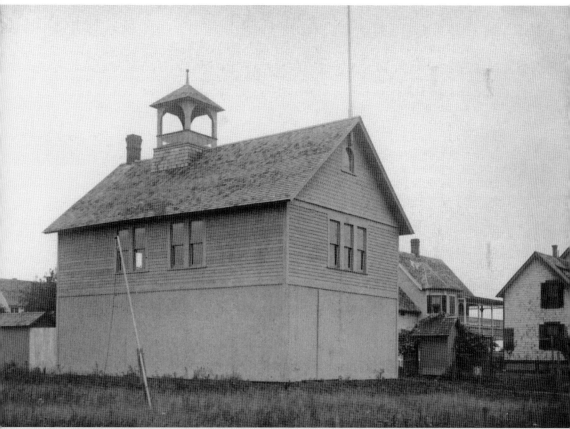

The Woodmont Fire Company was established in 1897 and housed in Edward Little's barn on Dixon Street, since the fire equipment was horse-drawn at the time. In 1949, the old wooden firehouse was replaced with a modern brick building at 128 Kings Highway. In 2017, the City of Milford regionalized its firehouses and the Woodmont station was closed.

As trolleys left the borough of Woodmont, they traveled west down Merwin Avenue. This photograph, taken at the Merwin Avenue trolley stop (signified by the white stripe on the telephone pole) in September 1932, shows three billboards in the field at the back, including one advertising Essolube. The sharp curve at Merwin Avenue is still the same, with a flashing curve sign, but condos instead of cottages line both sides of the street, and more condos sit where the billboards once were. (Past image, courtesy Shoreline Trolley Museum.)

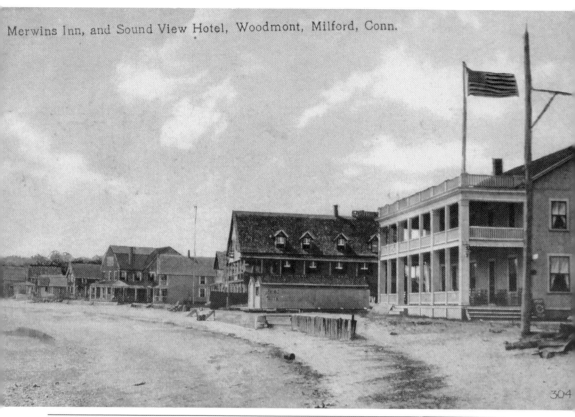

Merwins Inn, and Sound View Hotel, Woodmont, Milford, Conn.

304

Around 1900, Merwin's Beach had three famous landmarks: Merwin's Beach Restaurant and Inn on the right, the Sound View Hotel next to it, and Playridge Home for Crippled Children at center. Sylvester Poli purchased the two hotels in the early 1920s. He moved Merwin's Inn back and converted it into the largest Poli "cottage" at 10 Villa Rosa Terrace in 1925. Then, on the Sound View property, he built three more cottages at 12, 14, and 16 Villa Rosa Terrace. (Past image, courtesy Christopher Scanlon.)

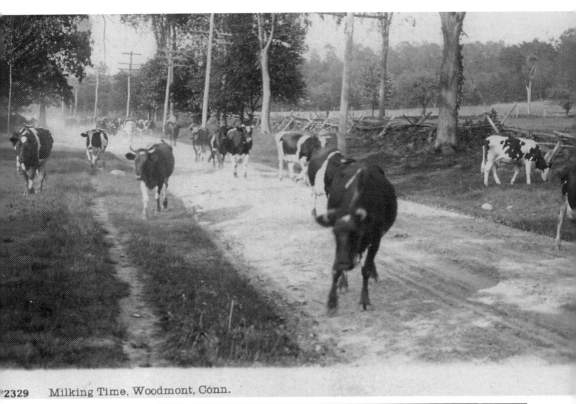

2329 Milking Time, Woodmont, Conn.

Farming has mostly disappeared from Woodmont, with the exception of Robert Treat Farm. There have not been milking cows in Woodmont since the early 20th century. These cows could have belonged to the Beach family farm or Bryan's dairy farm. Going back 200 years, the Bryan family had two houses and a dairy farm near the intersection of Merwin Avenue and Chapel Street. This photograph may have been taken on Chapel Street heading toward Bryan's or here on Treat Lane (the Dunbar Road extension).

Now an apartment at 30 Village Road, this 1910 shingled building was the original Woodmont Post Office—the first of three locations on what was then Cherry Street. In the 1930s, it moved to the corner of Cherry Street and Hawley Avenue, in the former Schonenberger's Meat Market (constructed in 1905), an imitation brick building that ended up as Rocco's Pizza. Its third location was a brick building at 27 Village Road (constructed in 1950) until it closed in 1995. Woodmont once had its own zip code: 06465.

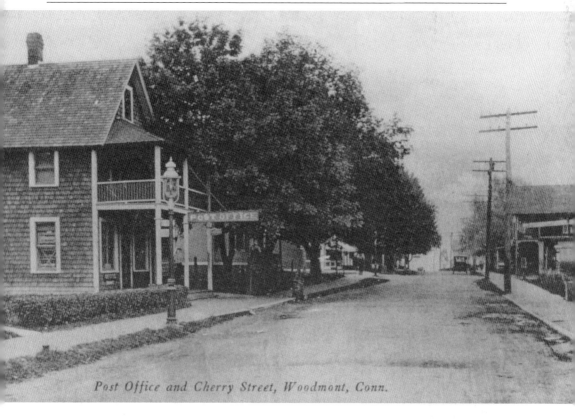

Post Office and Cherry Street, Woodmont, Conn.

Joseph Hawley (1826–1905) was one of Connecticut's prominent figures—a lawyer, journalist, Civil War general, governor, US senator, and congressman. The July 8, 1895, issue of the *New Haven Morning Journal and Courier* reported that "Senator Joseph Hawley and family are domiciled at their summer cottage. The general appears to be taking solid comfort at this great resort by the sea, where the cares of state are forgotten." His cottage at 96 Hawley Avenue was razed in 2015. A lovely home was built, but a piece of history was lost.

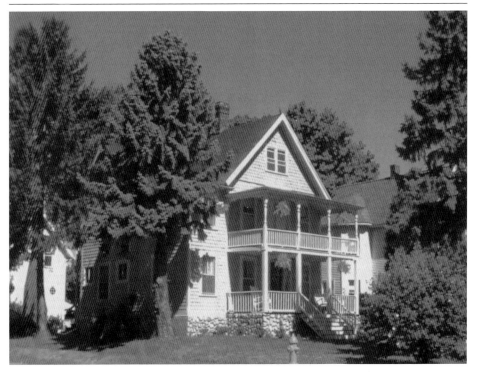

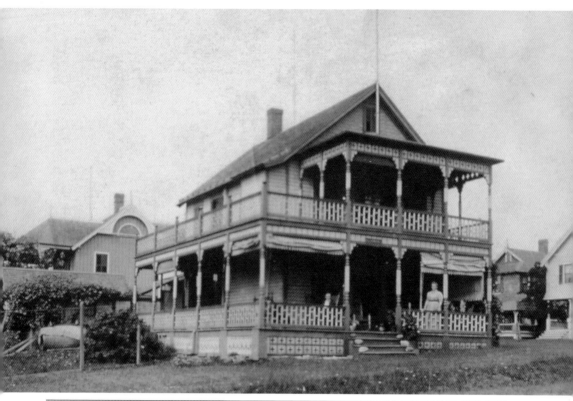

This forgotten cottage at the corner of Hawley Avenue and Dunbar Road was typical of the gingerbread architecture that was popular in the United States, particularly on the East Coast, in the late 19th and early 20th centuries. It was similar to the more elaborate Victorian-era style, which added gables and turrets but was simpler and less expensive, relying on boards cut into ornamental decor to transform simple frame homes into unique cottages. This house was torn down in 1989.

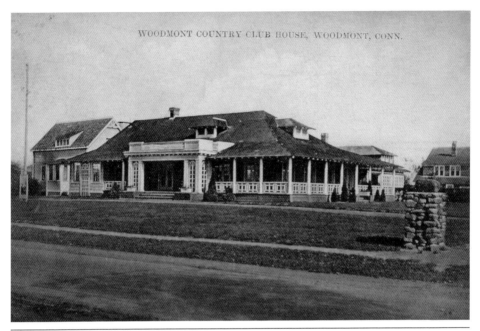

WOODMONT COUNTRY CLUB HOUSE, WOODMONT, CONN.

In 1896, twenty-five cottagers purchased $100 shares of the Woodmont Casino company to build a club with a large dance hall and billiard room. It opened around 1900 as the Woodmont Country Club on New Haven Avenue between Clark (Bonsilene) and Curfew (Wall) Streets. In 1954, St. Agnes Chapel spent $1,800 to buy the then vacant building for a parish hall until the new St. Agnes Church opened on Merwin Avenue in 1960. A home replaced the landmark after it was razed in the 1990s.

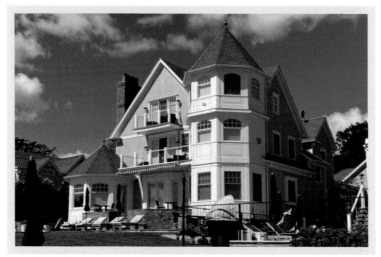

Around 1900, Christodora Cottage at 15 Beach Avenue housed 15 New York City children every two weeks each summer. The cottage was owned by the Christodora Settlement House, founded in 1897 to help immigrant families from the Lower East Side adjust to life in a new country. In the mid-20th century, G. Roy and Olive Fugal purchased the lovely Victorian house and raised their family there. In 2005, it was sold, razed, and replaced by a modern, elegant, 6,000-square-foot house. (Past image, courtesy Joseph Holt Collection.)

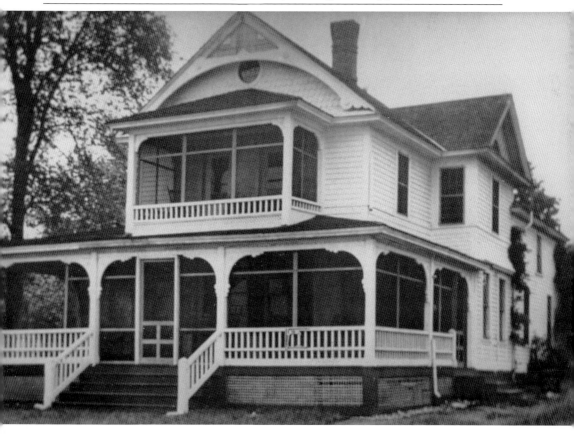

DISCOVER THOUSANDS OF LOCAL HISTORY BOOKS FEATURING MILLIONS OF VINTAGE IMAGES

Arcadia Publishing, the leading local history publisher in the United States, is committed to making history accessible and meaningful through publishing books that celebrate and preserve the heritage of America's people and places.

Find more books like this at
www.arcadiapublishing.com

Search for your hometown history, your old stomping grounds, and even your favorite sports team.

Consistent with our mission to preserve history on a local level, this book was printed in South Carolina on American-made paper and manufactured entirely in the United States. Products carrying the accredited Forest Stewardship Council (FSC) label are printed on 100 percent FSC-certified paper.

MADE IN THE USA